HOW TO **SEE**, HOW TO **DRAW**

How to See,

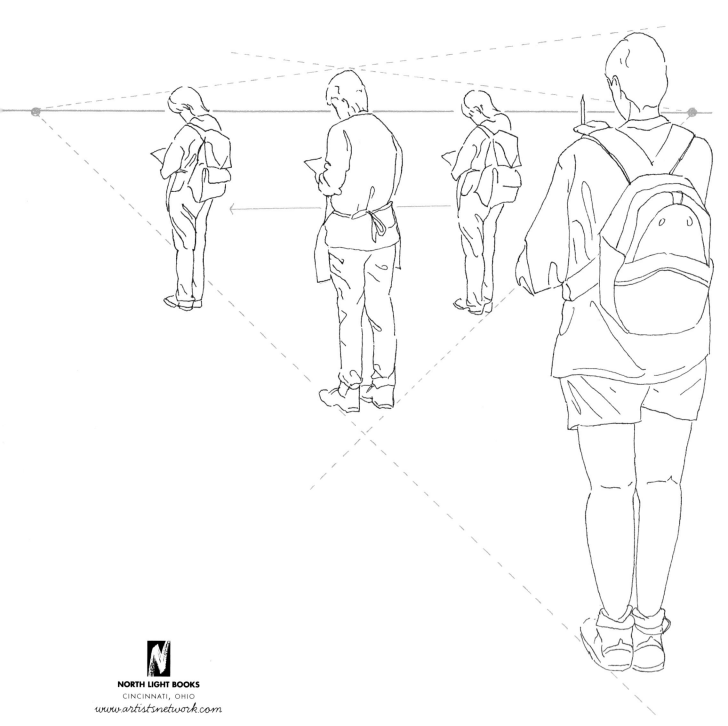

NORTH LIGHT BOOKS
CINCINNATI, OHIO
www.artistsnetwork.com

How to Draw

Claudia
Nice

Other fine North Light Books are available from your local bookstore, art supply store, online supplier or visit our website at **www.fwmedia.com**.

16 15 14 13 12 9 8 7 6 5

Distributed in Canada by Fraser Direct
100 Armstrong Avenue
Georgetown, ON, Canada L7G 5S4
Tel: (905) 877-4411

Distributed in the U.K. and Europe by David & Charles
Brunel House, Newton Abbot, Devon, TQ12 4PU, England
Tel: (+44) 1626 323200, Fax: (+44) 1626 323319
Email: postmaster@davidandcharles.co.uk

Distributed in Australia by Capricorn Link
P.O. Box 704, S. Windsor NSW, 2756 Australia
Tel: (02) 4577-3555

Library of Congress Cataloging-in-Publication Data
Nice, Claudia
 How to see, how to draw : keys to realistic drawing /
Claudia Nice -- 1st ed.
 p. cm.
 Includes index.
 ISBN: 978-1-60061-757-7 (hardcover : alk. paper)
 1. Drawing--Technique. 2. Realism in art. I. Title. II. Title: Keys
to realistic drawing.
 NC730.N53 2010
 741.2--dc22
 2010004360

Edited by **Kathy Kipp**
Designed by **Jennifer Hoffman**
Production coordinated by **Mark Griffin**

ABOUT THE **AUTHOR**

Claudia Nice is a native of the Pacific Northwest and a self-taught artist who developed her realistic art style by sketching from nature. She is a multi-media artist, but prefers pen, ink, and watercolor when working in the field. Claudia has been an art consultant and instructor for Koh-I-Noor/Rapidograph and Grumbacher. She represents the United States as a member of the Advisory Panel for The Society Of All Artists in Great Britain.

Claudia has traveled internationally conducting workshops, seminars and demonstrations at schools, clubs, shops and trade shows. She operates her own teaching studio, Brightwood Studio (www.brightwoodstudio.com) in the beautiful Cascade wilderness near Mt. Hood, Oregon. Her oils, watercolors, and ink drawings can be found in private collections nationally and internationally.

Claudia has authored more than twenty successful art instruction books. Her books for North Light include *Sketching Your Favorite Subjects in Pen & Ink; Creating Textures in Pen & Ink with Watercolor; How to Keep a Sketchbook Journal;* and her latest book, *Down By the Sea with Brush and Pen,* published in 2009.

When not involved with her art career, Claudia enjoys gardening, hiking, and horseback riding in the wilderness behind her home on Mt. Hood.

ACKNOWLEDGMENTS
A special thank you to my editor, Kathy Kipp.

METRIC CONVERSION CHART		
TO CONVERT	TO	MULTIPLY BY
Inches	Centimeters	2.54
Centimeters	Inches	0.4
Feet	Centimeters	30.5
Centimeters	Feet	0.03
Yards	Meters	0.9
Meters	Yards	1.1

Even the raptors,
the masters of the sky,
began life as an egg.

Table of Contents

Introduction

Although there may be some artists who do not work up to their potential, possibly due to fear of moving out of their comfort zone, I hesitate to label anyone's artwork good or bad. A drawing or painting is merely a reflection of how advanced a person is in his or her skills of observation and brain-to-hand interpretation. Some artists strive for a sense of mood or feeling rather than an accurate representation of the subject, even though they have developed observational skills. This is a choice of style and is not necessarily bad art.

This book is for those who wish to develop their representational drawing skills. Just as young children learn to create the alphabet letters, I believe that drawing skills can be taught and improved upon through practice. It's true that not all children go on to develop legible handwriting. Some become careless, content with whatever flows from their hand. Others just say "I can't do better," when their early handwriting was just fine. Then there are those who would rather interpret the alphabet letters in their own manner—the abstract hand writers. Adults who have beautiful handwriting are not born with it; they develop it and maintain it with practice and discipline. So it is with drawing skills.

The first step is to develop a proper attitude. Saying "I can't" is the same as saying "I'm not willing to try." An "I can't" attitude allows one to remain safely stagnant. You, who are exploring the pages of this book, are entertaining the idea that your work can be improved upon, and that is a very good way to start.

Step two is to banish the childish symbols and preconceived ideas from your work. They interfere with your ability to see and interpret your subject in a realistic manner. Preconceived notions of how a subject is supposed to look are always in our minds and will pop into our drawings when we are overwhelmed or confused with what we are "seeing" in our subject. Chapter Two will help you understand and get past your preconceived ideas.

Step three is learning the skill of observation. Not only will this improve your drawings, but you will begin to see the world around you in a richer, more detailed manner. Colors and contrasts will be more vivid. Shapes will be more apparent, and textures will touch your senses before you make contact with them. Observation is fundamental to the creation of accurate drawings—and learning better ways to observe the subject is what this book is all about.

The last step in developing your drawing skills is up to you: Practice, practice, practice!

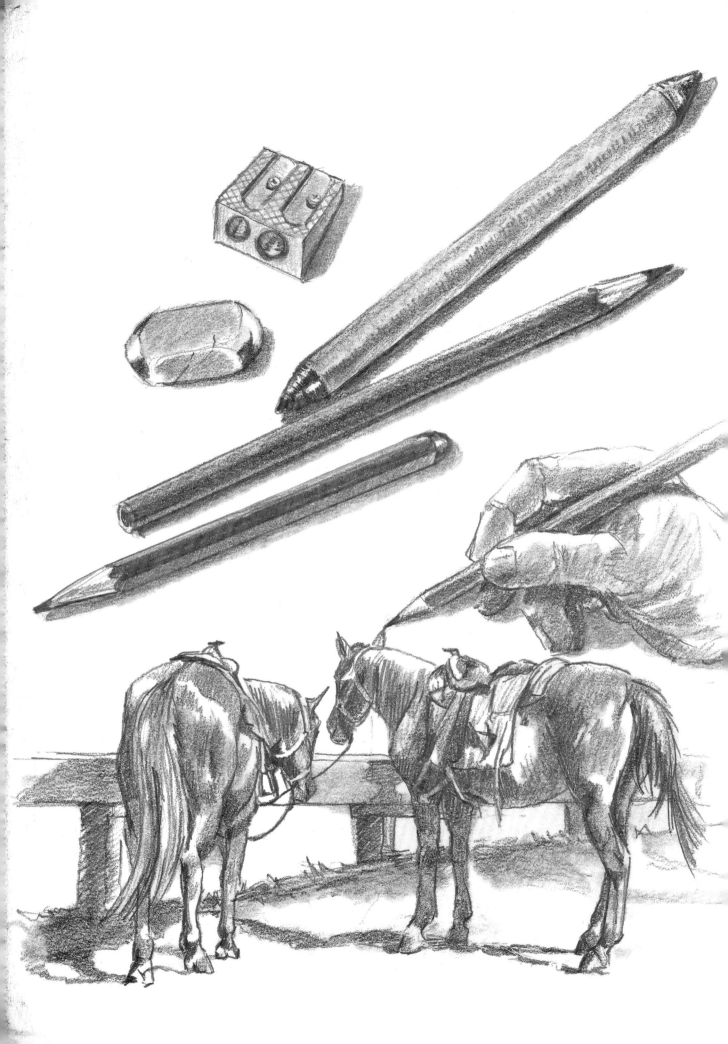

Tools and Marks

The oldest dark-toned drawing medium is charcoal, snatched from the cooling embers of the fire pit and smeared on cave walls in the image of animals, hunters and primitive symbols. Time passed and lead deposits were discovered.

The first "pencils" were thin, lead sticks that left marks when scratched across a pale papyrus surface. Although pencils no longer contain lead, the marking part of the pencil is still referred to as the "lead." Today's pencils have come a long way and are a favorite art medium.

Charcoal, in its modern refined form, is still a popular drawing medium. It comes in broad sticks, slender vine charcoal sticks (which are a softer variety), and charcoal pencils that are encased in wood or paper to keep your fingers clean.

This chapter will help you get better acquainted with drawing tools and show you how to use them to your best advantage.

Vine charcoal stick

Charcoal pencil

Pencils and Charcoal

GRAPHITE **PENCILS**

The lead in graphite pencils consists of a compressed mixture of graphite powder and clay. The more clay placed in the graphite mixture the harder the lead becomes. "H" stands for hardness, with 9H being the hardest drawing pencil with the greatest amount of clay and the palest mark. Drawing pencils H, 2H, 3H and up to 9H will maintain a very sharp point and are good for fine detail work and for creating narrow, precise lines in a light gray tone.

"B" stands for blackness. Drawing pencils marked with a B have a greater concentration of graphite in the mix and are softer and darker in tone than the H pencils. HB, B and 2B pencils maintain a good point and have a medium dark tone. These leads are commonly used in writing pencils and are good for general sketching. Pencil leads 3B through 9B get progressively darker. They can be sharpened to a nice point, but because of their softness, they will quickly wear down to a wide, blunt tip. Pencils marked 4B and above are useful for making broad, dark lines, for filling in shadow areas and for creating rich, graduated value tones.

Shown below are the H and B pencils I use most often in my drawings.

Pencils come in a variety of shapes and sizes. When making your choice, you need to consider what type of line you desire (bold or precise), where you will be sketching (studio or field work) and what feels good in your hand.

Carpenters' pencils and woodless pencils (coated with a thin layer of plastic) create bold lines and can be whittled to produce blunt, chiseled edges.

Mechanical pencils and lead holders consist of a plastic or metal holder and a graphite lead. The lead is replaceable and is designated by its width in millimeters, and its hardness. The advantage of mechanical pencils is that the lead is advanced manually and does not require a sharpener. This makes it ideal for journaling or field work. Most mechanical pencils have a built in, extendable eraser.

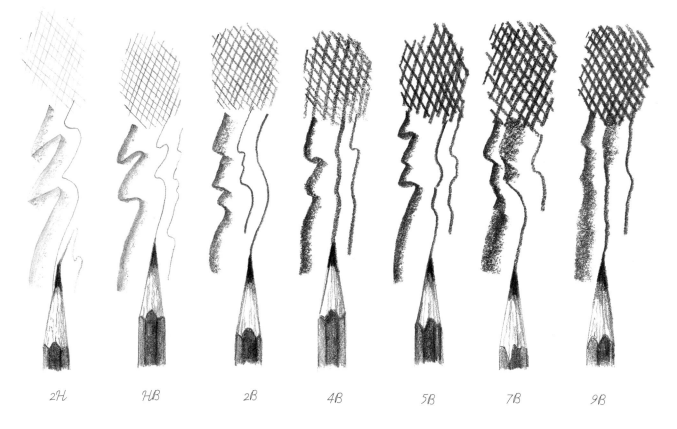

2H HB 2B 4B 5B 7B 9B

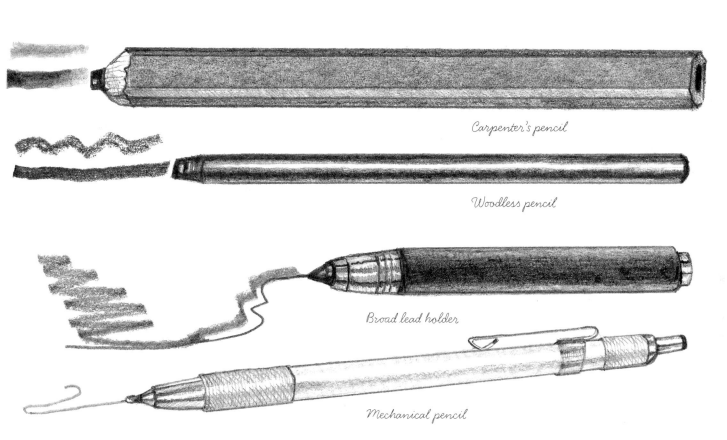

Carpenter's pencil

Woodless pencil

Broad lead holder

Mechanical pencil

Both drawing pencils and writing pencils generally come encased in wood with a hexagonal shape to prevent them from rolling away. The hardness of the pencil lead is indicated on the side of the pencil. The big difference between them is that writing pencils have built-in erasers, while drawing pencils do not. Drawing pencils also have a greater range of hardness/softness to choose from.

When working with wooden pencils, you will need one or more sharpening tools and an eraser. The erasers on the ends of writing pencils are convenient, but do not last long.

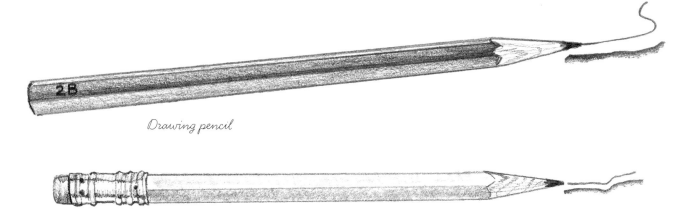

Drawing pencil

Writing pencil

11

SHARPENERS

To put a nice point on a drawing pencil, an electric pencil sharpener or a "carry along" manual variety will do. There are also specially designed sharpeners to put a crisp point on the leads used in lead holders and the larger mechanical pencils. However, if you want to create a broad chisel point, you will have to resort to wearing the lead down or whittling. A razor blade, X-acto knife or pocket knife will work well to scrape away the unwanted wood and form the chisel shape. To fine-tune the edge and maintain it, you will need to rub the lead across a piece of fine sandpaper or an artist's sanding block.

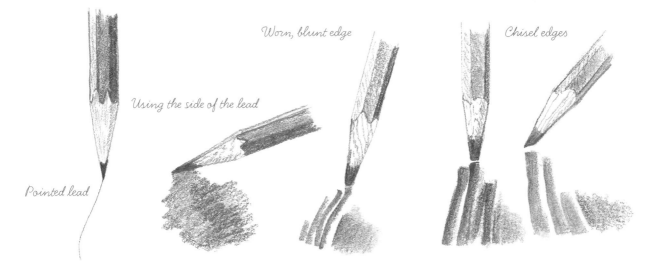

Using the side of the lead

Worn, blunt edge

Chisel edges

Pointed lead

ERASERS

Gum erasers work well, but leave a lot of debris behind. I prefer kneaded erasers or soft, white vinyl erasers, which come in blocks or in long, rounded strips. Kneaded erasers work especially well when used with an eraser template.

Keep in mind that erasers can do more for the artist than rubbing out mistakes. They are a great tool for adding highlights and light toned texture.

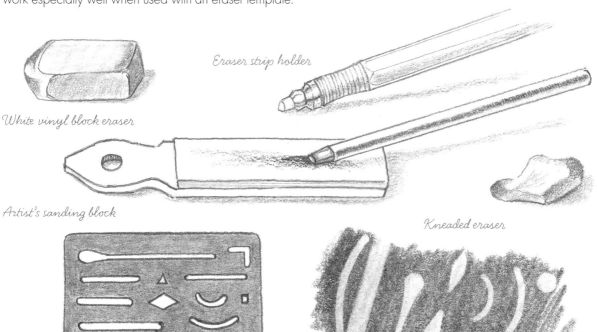

White vinyl block eraser

Eraser strip holder

Artist's sanding block

Kneaded eraser

Erasing template

Erased with template

HOLDING THE PENCIL

Hold your pencil so it feels comfortable in your hand, with a relaxed grip. Arrange the pencil in the same manner as you would for writing, with your fingers at least an inch above the lead, for the greatest control. Use both finger and wrist action in your strokes.

To produce free, sweeping strokes, hold the pencil between the thumb and forefinger with the butt of the pencil resting firmly against your palm. Use wrist and arm action, rather than finger motion.

The effects produced by your strokes will depend on your finger, wrist and arm movements, how your lead is shaped, the lead hardness/blackness and how much pressure is used. Below are a few basic strokes to become familiar with. Additional stroking ideas can be found in Chapter Eight.

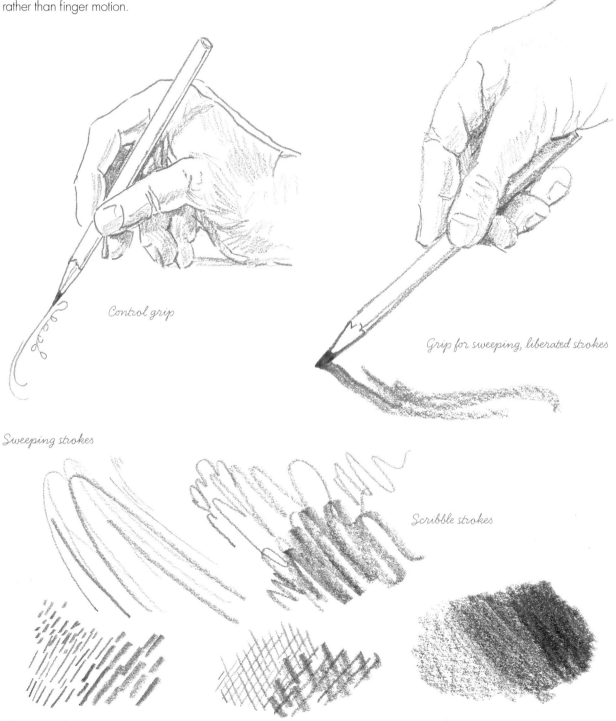

Control grip

Grip for sweeping, liberated strokes

Sweeping strokes

Scribble strokes

Hatch marks

Crosshatch

Solid tone

CHARCOAL

Today's charcoal is made in several ways. Natural charcoal consists of twigs and vines that are heated without air until they char. Natural charcoal is brittle and provides a dark, coarse line.

Compressed charcoal consists of ground charcoal and stabilizing ingredients that are pressed into sticks or slender pencil leads. Compressed charcoal is smoother, darker and less apt to break than the natural variety.

Depending upon the wood used, the charring temperature, how long it was cooked and what was added to the charcoal when it was compressed, the resulting sticks and pencils come in a range of soft (B) to hard (H). There is also a white charcoal pencil that can be used to add highlights to charcoal drawings rendered on colored or gray-toned papers.

The advantage of charcoal is that it produces broad, dark strokes that readily cover large areas. It smears and blends easily to produce gradated values.

THE **SMEAR** FACTOR

One of the best perks in using charcoal or graphite as your sketching medium is that it smears. By rubbing across the strokes, you can smooth them, blend them or create a soft, graduated change of value. The drawback is that smears show up where they're not wanted. To prevent unwanted pigment transfer, I place a sheet of clean notebook paper under my hand while I'm drawing. Workable fixative spray can be used to protect sections of completed work. It's invisible, dries quickly, and prevents smearing. Lines and marks can be worked over it without a problem.

BLENDING TOOLS

Fingers make fair rubbing tools, but are too broad for detail work and are messy. I prefer to use blending tortillions, which are sturdy tubes made of rolled paper that are pointed at one or both ends. Larger varieties are sometimes referred to as paper stumps, blending stumps or stubs. They do a good job of blending. Used, pigment-coated tortillions will lay down lines and patches of soft, gray tones.

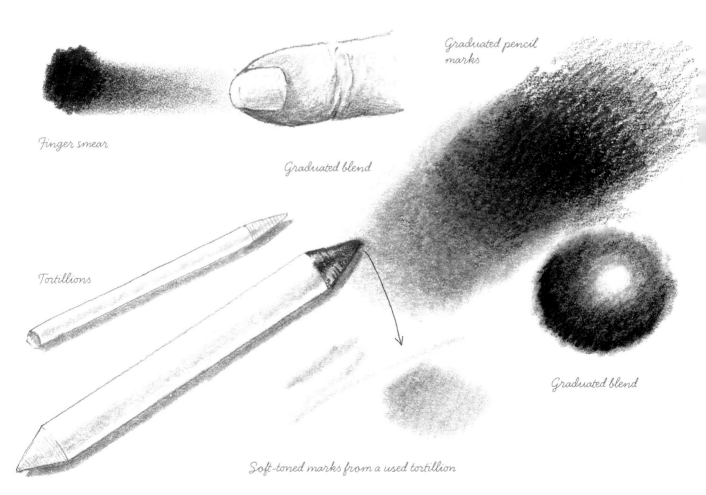

Finger smear

Graduated blend

Graduated pencil marks

Tortillions

Graduated blend

Soft-toned marks from a used tortillion

DRAWING **SURFACES**

The biggest consideration in selecting a drawing paper is its tooth—the roughness of its surface. The tooth helps the pigment cling to the paper's surface. For pencil drawings with a range of H and B leads, choose a quality paper with a medium tooth. My personal favorite is a 90-lb., off-white, all rag, pH neutral, professional grade paper. Bristol paper and illustration board with a slight tooth will also work well. For charcoal drawing, choose a coarser paper with a heavier tooth to trap the larger particles.

USING A **VIEWING GRID**

Having a viewing grid will help you in making correct observations when drawing freehand. You can make one yourself by inking equally spaced vertical and horizontal lines on a sheet of clear plastic, or you can use a Gridvu™ (www.gridvu.com).

I came across the Gridvu while browsing in a college book store. It is a viewable grid system printed on a 5½-inch (14cm) square of hard, clear plastic, with a level attached to the top. The bubble in the level ensures that the horizontal and vertical reference lines are accurate. To assist in drawing the human figure in correct proportions, there is a diagonal line with a half-skull printed at the top. The line is marked off in skull lengths to help you determine how many head lengths are in the total length of the body.

To make the comparison, you simply rotate the Gridvu plate and move your position forward or backward until the printed skull can be superimposed with accuracy over the head of the model. Then note how many skull-lengths there are between the crown of the head and the bottom of the feet. You can also tell at a glance how the different parts of the body compare in size to the head.

The advantages of using a grid or the Gridvu are:

✳ Locating the center of your subject or scene easily

✳ More accuracy in seeing lines, shapes and subtle variations

✳ More accuracy in determining curves and angles

✳ It provides a consistent framework from which to enlarge or shrink the size of your drawing

An in-depth look at how such comparisons can help you improve your drawing skills is shown in Chapters 4 and 5.

A few other useful drawing tools include:

✳ A smooth drawing board to support your drawing surface

✳ Drafting tape or clamps to fasten drawing paper to the board. (Masking tape will work if great care is used when removing it.)

✳ Conté pencils or colored pencils if you wish to draw in rich shades of Sienna, Umber or Sepia

✳ A soft brush to whisk away eraser crumbles

✳ An eraser template for lifting small areas of pigment

✳ A digital camera for creating a backup photo reference when working in the field or from live subjects

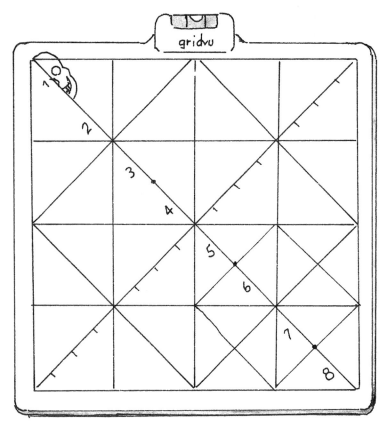

Sketch of a Gridvu

Pen and Ink

DIP PENS

Today's dip pens are an adaptation of the early feather quill pens. They consist of a plastic or wooden nib holder and a removable steel nib. They are inexpensive and easy to clean. Hunt Nibs no. 104 (fine) and 102 (medium) will provide a precise, delicate ink line. However, dip pens are limited in stroke direction, have a tendency to spatter, and the re-dipping process interrupts the stroking rhythm.

FIBER-TIP PENS

Felt and fiber-tip pens are both convenient and economical. They have evolved from the broad-tip marker into a reliable art tool with a wide range of nib shapes and sizes. The ink flow is instantaneous, making them ideal for fast sketching. Pigma Micron pen size 005 lays down a very fine line. Faber-Castell's Pitt artist pen also comes in a fine line and a brush nib that varies its stroke width according to the pressure applied. Both of these pens contain permanent ink that does not run if it gets rained on in the field or deliberately brushed over with a wash of color. Fiber-tip pens do have a few drawbacks. The tips wear down and the pens run out of ink with little warning. It's best to have duplicates of your favorite fiber-tip pens on hand.

TECHNICAL PENS

Once used for drafting, the technical pen produces a very precise line that can be stroked in any direction. It consists of a hollow metal nib, a self-contained ink supply (either a prefilled or refillable cartridge) and a plastic holder. Within the hollow nib is a delicate wire and weight, which shifts back and forth during use, bringing the ink supply forward. A very fine line is available with the .13 mm and .18 mm nibs, but I find the range of nibs from .25 mm to .50 mm to be sturdier, giving you a good variety of line widths. The larger sizes are handy for filling in solid black areas. Technical pens are the most accurate and most expensive of all the ink application tools. Like any fine instrument, they require cleaning and maintenance, and will clog if neglected or abused. The technical pen I prefer is the Koh-I-Noor Rapidograph.

Pitt Pen (brush nib)

Fiber-tip pens

PIGMA MICRON 005 XI ARCHIVAL INK

RAPIDOGRAPH® KOH-I-NOOR®

Technical pen

05

005

.25mm

.30mm

.35mm

.50mm

2mm

Dip pen

INK

The ink used in the pen is just as important as the tool used to apply it. Choose a pigmented ink with a permanent base such as shellac for black India ink and acrylic for colored inks. Avoid dye based inks, which tend to fade over time. If you are going to be applying the ink in a technical pen, make sure the label states that it is recommended for such a tool. The larger pigments in opaque inks will clog the technical pen. My favorite inks are Koh-I-Noor Universal Black India Ink 3080 and Daler-Rowney FW Acrylic Artists Ink (transparent).

INKING **SURFACES**

An absorbent paper with a firm polished texture provides the best surface for pen and ink work. The pen should glide over the paper without snagging, picking up lint or clogging, and the ink should neither bleed nor bead up as it is applied. Ink lines should be sharp-edged and precise in appearance. I have found hot-press illustration board, Bristol boards, hot-press watercolor paper, parchment paper and vellums work well for pen and ink. Drawing paper is the most economical drawing surface, but there are a great number of grades and varieties. A frayed line is a good indication that the paper is too soft for ink work, even if it is labeled "for use with ink."

Other useful pen and ink tools are:

✳ A technical pen cleaning kit, as eventually your technical pen will need to be cleaned. The Rapido-ease kit by Koh-I-Noor includes a handy syringe for flushing out the inner workings of the pen. Hint: if you avoid shaking the pen to get it started, but rather turn it butt-side down to the table and tap it gently, you will experience less clogging and cleaning time. Hint number two—never remove the wire inside the nib.

✳ White correction fluid for covering up small mistakes. The only way to correct big inking mistakes is to cleverly ink on top of them or start over.

✳ A razor blade to scrape away small mistakes or scratch in small highlight spots.

✳ Masking fluid for protecting a white line while you apply ink next to it. I find a Masquepen (shown at left) or Daniel Smith Artist Masking Fluid works very well for this. However, be careful not to disturb the dry line of masking fluid as you stroke up against it.

Sketchbook Journal

The quickest way to improve your drawing skills is to practice every day. The most convenient way to do that is to get a small sketchbook journal and carry it with you, along with your favorite pen or pencils. When interesting subjects appear, you will be able to capture the essence of them. Add a few notes such as the date, where it was sketched and a brief description. Journal sketches can be as simple or as detailed as you have the time or the desire to make them. Don't worry about how "good" the sketches turn out. The sketchbook journal is a private place that you do not have to share with others unless you want to. The important thing is that you are drawing and the results are recorded on the bound pages so that you can follow your progress.

The entries on these pages are taken from the various journals I have kept. As time has passed, they have become more than lines set down on paper—each one represents a precious memory.

Prairie Crocus
Winnipeg, Canada
March 1984

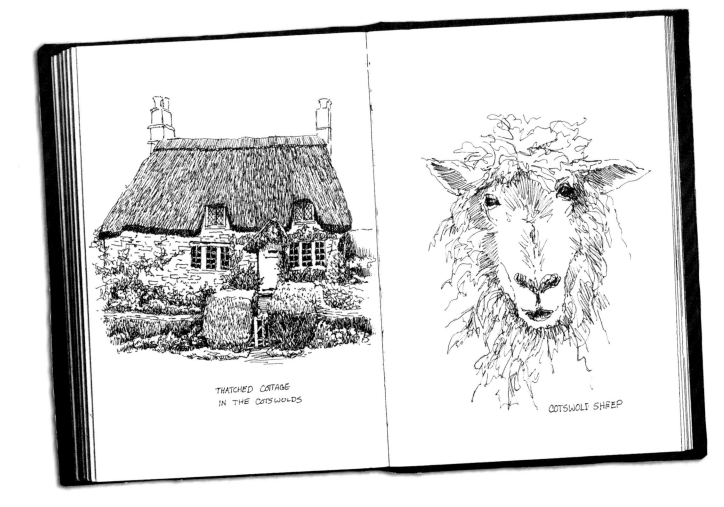

THATCHED COTTAGE
IN THE COTSWOLDS

COTSWOLD SHEEP

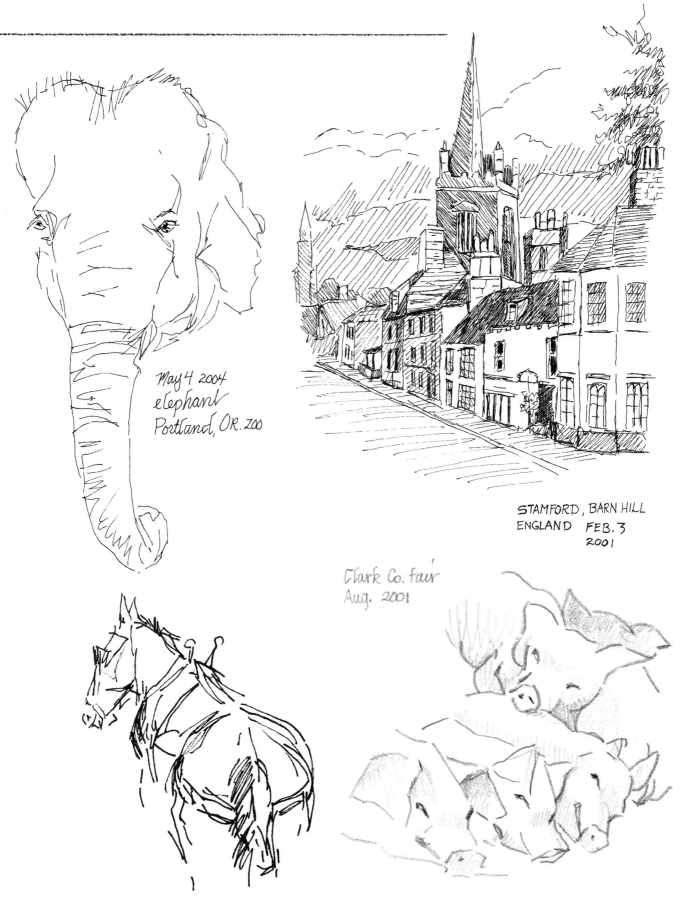

May 4 2004
elephant
Portland, OR. Zoo

STAMFORD, BARN HILL
ENGLAND FEB. 3
 2001

Clark Co. fair
Aug. 2001

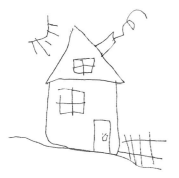 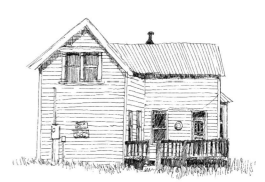

This is the work of a young child. Although some observation skills were used in adding the fence and a window in the upper story, most of the drawing reflects the use of preconceived ideas.

This drawing shows that the artist was aware of the basic shape of the house. However, when it comes to the tricky side wall, where the front of the house joined the back, it was simply ignored.

This sketch shows that the artist studied the subject and was able to draw it with a fair amount of accuracy. The two trouble spots are the side wall and the diagonal lines on the roof, both of which are out of perspective. Some comparative work using a straight edge would have helped the artist to see these areas more clearly.

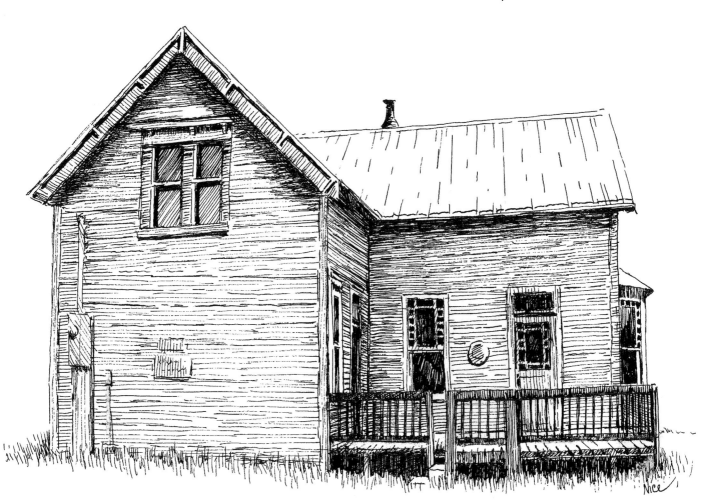

This house was drawn by the author using a lot of comparative observation. Making numerous comparisons between the shapes, lines and angles of the subject and those of the drawing enables the artist to see what is happening more clearly. Preconceived ideas are kept to a minimum.

2 Seeing Past Preconceived Ideas

Observation and practice are the keys that enable a person to draw well. Although one may be born with a patient, inquisitive nature, the skills of observation may be developed by almost anyone. However, there is a major stumbling block that stands in the way of the developing artist: preconceived ideas. We learn basic shapes as babies. Mother's face is an oval. She has two orb-shaped eyes that focus on us, giving us her attention. Her smile, which we see as an upward curving bow, expresses her approval. It's no mystery where the "happy face" symbol comes from. It is one of our first preconceived ideas of what a friendly human face should look like, in its most primitive form.

Symbols are simple shapes used to represent an object or idea. They correspond to the preconceived ideas that are basic to most of us and are readily recognized. Think about the symbols used on road signs and on warning labels. Preconceived ideas are very apparent in the early drawing attempts of children. They don't study the subject they are drawing, but rely on simple symbolic shapes to express themselves. When a young child draws a house, it doesn't matter what the house actually looks like; it will most likely be portrayed as an irregular square with a triangular roof, a big rectangular door and a few box shaped windows. If there is a chimney, it will probably be sticking out of the roof at an angle. This doesn't mean that the child sees the house in this manner; it simply means that symbols are safer and easier to put down on paper than reality. It's encouraging to know that even young children can be taught to be observant. As they develop their observation skills, they begin to transfer what they see into their art, replacing symbolic representation.

Overcoming preconceived ideas is an ongoing process. It involves studying the actual shape, size and position of the subject you are drawing and making continuous comparisons. It means seeing the way in which the light and shadows play over the surface of the subject and how well-defined its edges are. Textures need to be registered in the sensory portion of the mind, and if possible, actually touched. Color is an important observation too, even for those working in tones of gray, because changes in hue and intensity can be represented by changes in value. The drawings shown at left are of the same house and were drawn by different people with varying observation skills.

Observational Skills

The drawings on these two pages were created by adults with different observational skill levels. They all used the photograph of the boy with the curly hair to work from. How closely they studied the photo as they worked is reflected in their drawings.

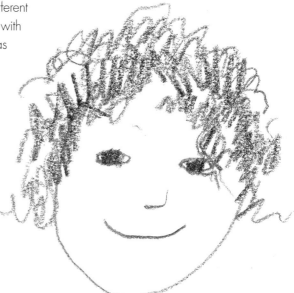

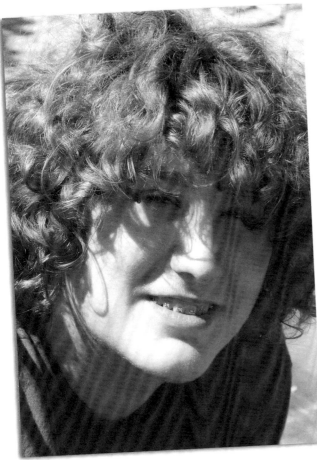

Here is a reference photo of "the boy with the curly hair."

Although the sketch above was done by a self-proclaimed "non-drawer," she did manage to capture both the happy mood and the curly hair of the subject. The face shape and simple facial features are universally recognized traditional symbols. Substituting symbols for accuracy can occur any time a person is working beyond their comfort zone.

This drawing is more accurate in the shape of the face, mouth and nose. The artist noted that the head is turned and that there is less of the face showing on the right side than the left. However, she did not interpret the tilt of the head correctly. The chin and mouth are at a slight angle, but the nose, eyes and upper head are straight across. A preconceived idea convinced the artist to add the whites of the eyes in the drawing even though they are mostly hidden in the photo.

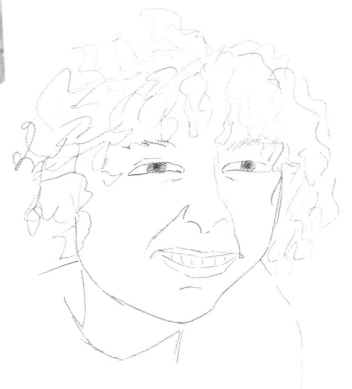

The tilt of the head and the facial features in this drawing show that the artist took some time to study her subject and make comparisons. Unfortunately, one preconceived notion did slip through. Knowing that faces are symmetrical kept the artist from seeing that the face in the photo is turned slightly. She drew it evenly on both sides.

And finally, this is a recognizable drawing accomplished with much study of the subject. Compare it to the progressing work shown on the previous page and above. Note how the soft value changes in the shadows add realistic contours to the face.

COLUMN A

Drawing symbols based on preconceived ideas.

COLUMN B

Drawings that are strongly influenced by preconceived ideas. The use of heavy outlines suggests insecurity in moving away from drawing symbols.

COLUMN C

Drawings that reflect the natural shapes, shadows and edges observed in the subjects.

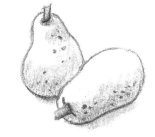

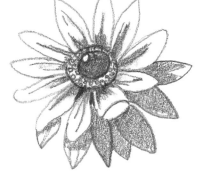

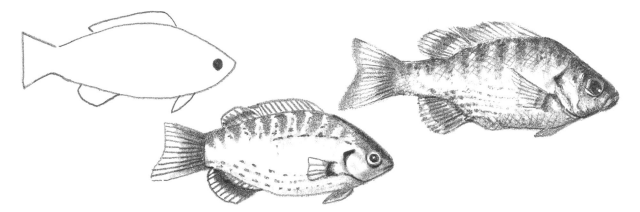

PRACTICE **EXERCISE**

If you can't put a name to the object you are drawing, it's not likely that your mind will predetermine how that object should look in a drawing. Below are two drawing exercises that will help you banish preconceived ideas while you observe and draw.

Begin by drawing two squares with the sides at least 3 inches (7.6cm) long. Squares that are much smaller than this will cramp your work space. Keep in mind that teeny tiny drawings allow the creation of teeny tiny errors, which are much harder to see and correct.

Working within a square will provide vertical and horizontal boundary lines for making comparisons. As you observe the shapes within the square's perimeter, ask yourself these questions:

✳ How close to the perimeter is each shape?

✳ How do the angles formed by the shapes compare to vertical and horizontal?

✳ Do the shapes cross through the center of the square and if so, by how much?

✳ How does each shape compare in size to the others around it?

✳ What do the empty spaces surrounding the shapes look like and how large are they?

Making these comparisons will help you see the subject in a new, more comprehensive way. Now, try to draw the shapes in the boxes with as much accuracy as you can.

Drawing Styles

One of the best ways of improving drawing skills is sketching. A sketch is merely a casual drawing, containing enough of the essential elements to describe the subject, but is lacking areas of detail. Listed below are various types of sketches and drawings that can be used to enhance your observation skills and develop your hand and eye coordination.

EXTERIOR CONTOUR DRAWING (OUTLINE)

In this type of drawing, the artist's full attention is on the overall shape of the subject. A line is used to define the outside edge, while areas within the subject are ignored. Two or more objects may be incorporated within one outline. This type of drawing is useful in obtaining a feel for the general shape and mass of the subject, without worrying about details. This is the simplest drawing form and symbols are often portrayed in this style.

BLIND CONTOUR SKETCH

This is a spontaneous drawing in which the eyes of the artist remain on the subject and the work is completed with little or no eye contact with the drawing surface. The result should be a rough but recognizable version of the subject's form. This is a great warm-up exercise, which requires total concentration on the contour of the subject. Observation skills come into full play and preconceived ideas are banished.

CONTOUR LINE DRAWING (MAPPING)

Simple lines are used to define both the outer edge and the inner contours of a subject. Outlines may also be used to portray abrupt value changes within the subject. This style has a clean, crisp look that is popular with illustrators. Lightly drawn contour drawings are used as the preliminary step in more detailed and developed art pieces.

CONTINUOUS LINE DRAWING

A continuous flowing line is used to define the subject, moving from the outer edges to the inner contours as needed. This type of drawing is very fluid. It is a good practice style to loosen up the artist whose work is becoming too tight and rigid.

GESTURE SKETCH

A gesture sketch is meant to catch the essence of the subject and especially its action or pose. The look of reality is not important. Lines are quickly drawn in a loose, free manner, with emphasis on sweeping curves and movement. This style of drawing helps the artist capture the feel of the subject.

QUICK SKETCH

Quick sketching is a rapid method of drawing in which restated lines and scribbled shadows are used to capture as much of the subject as possible in a short amount of time. These drawings are useful as journal entries, field notes and for depicting subjects on the move.

VALUE DRAWING

In value drawings, the shadow areas of the subject are portrayed in patches of gray or black. Light areas are left undefined. The value contrast is extreme and dramatic.

DETAILED OR REFINED DRAWING

A detailed/refined drawing uses lines, marks, smudges and value changes to suggest the subject in a clean, well-defined manner. Stray and re-stated lines are minimal. Most detailed drawings are realistic in style, but refined drawings can also be abstract.

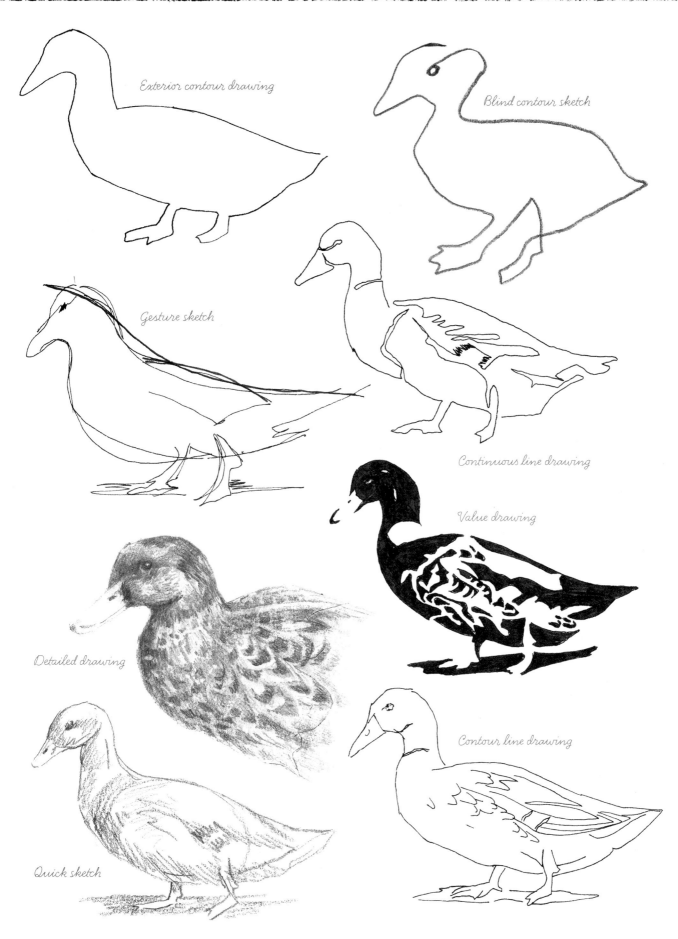

Exterior contour drawing

Blind contour sketch

Gesture sketch

Continuous line drawing

Value drawing

Detailed drawing

Contour line drawing

Quick sketch

Blind Contour Drawings

Crisp, white, empty sheets of paper can be intimidating. It's hard to set down that first line and get started. Making a blind contour drawing on scratch paper is a good way to loosen up and get over the fear of making a mistake. To make a blind drawing, place the subject at a distance from the drawing surface and concentrate totally on the form you are drawing. Do not peek at the drawing until you are finished. The results are loose and comical, but you may be surprised by how much of the form you have captured.

Besides being fun, blind contour drawings can help develop better drawing habits.

✳ When one is concentrating totally on the form of the subject, preconceived ideas can't enter into the drawing.

✳ Blind drawings heighten observation skills, encouraging the mind to see shapes, angles and sizes.

✳ We are less likely to overemphasize details when concentrating on the overall form.

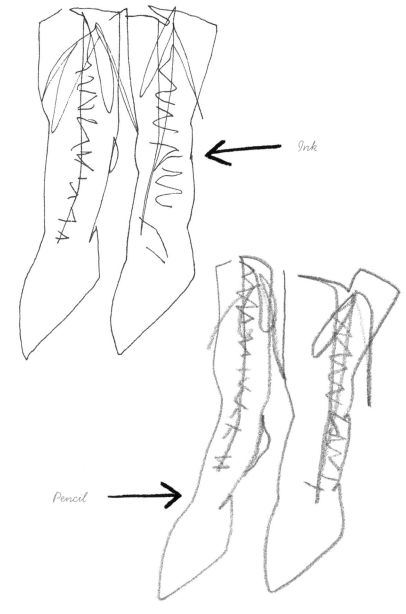

Ink

Pencil

Photo of old-fashioned, high-top shoes.

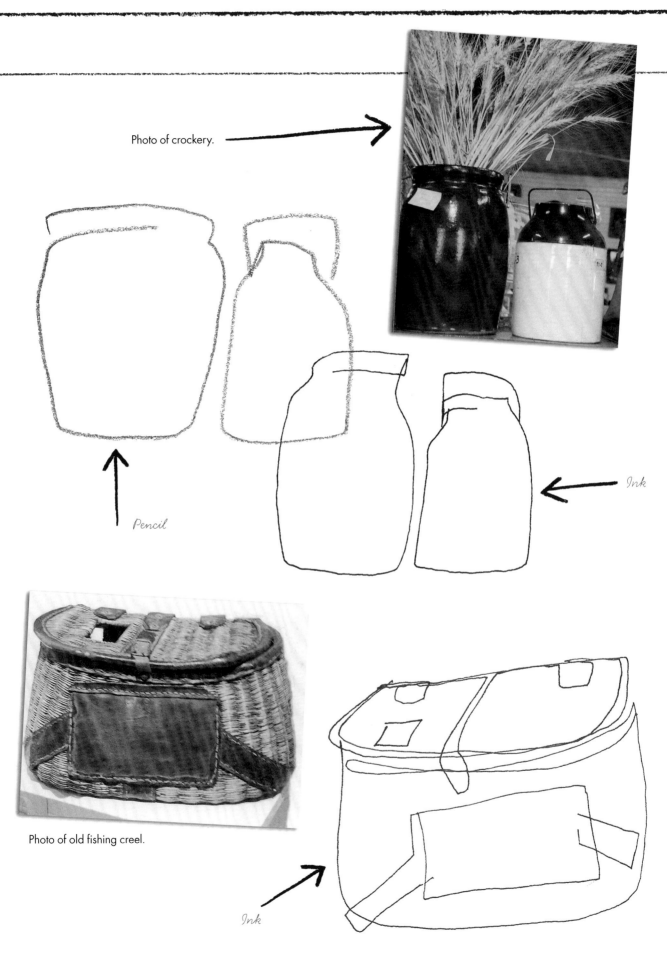

Photo of crockery.

Pencil

Ink

Photo of old fishing creel.

Ink

Comparing Symbols to Exterior Contour Drawings

Symbols are usually portrayed as flat, rigid shapes, while the lines of a contour drawing are more expressive, alluding to a dimensional form. This exercise will help you see the differences between symbols and natural forms. It is the first step in becoming more observant.

This is a symbol drawing of a crow. Note that the form is in profile, with the head up and only one leg shown. If we were to envision a standing crow in our mind, it would probably look somewhat similar.

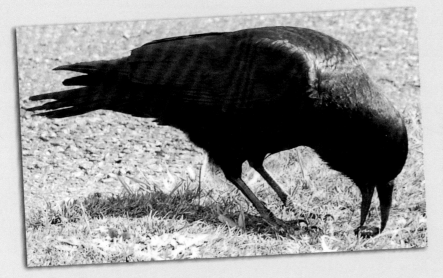

The crow in this photo differs greatly from the symbolic drawing above. Compare the differences in their stance and form.

Make a blind contour drawing using the photo as your subject. Combine both the crow and his ground shadow into one form. Although the results may look a bit comical, the blind contour drawing should be a loose suggestion of what you actually observe.

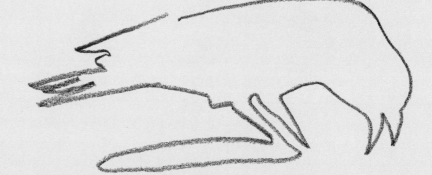

Blind contour drawing

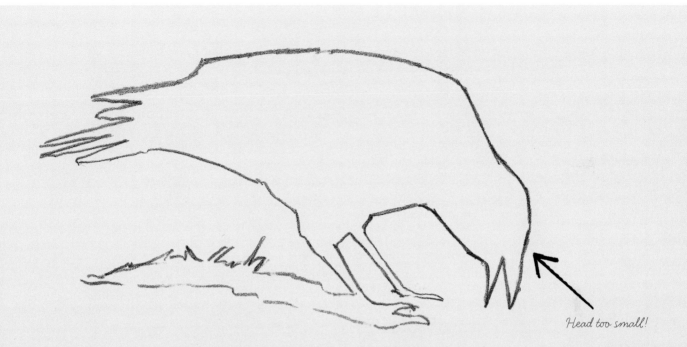

Head too small!

Make an outline drawing of the crow and his shadow. Although this time you can look at the drawing surface while you work, try to be just as observant as if you were working blind. Make size comparisons. Check the steepness of angles. If you locate an area that you can improve, erase and re-draw it.

Below is my exterior contour (or outline) drawing of the crow with corrections made.

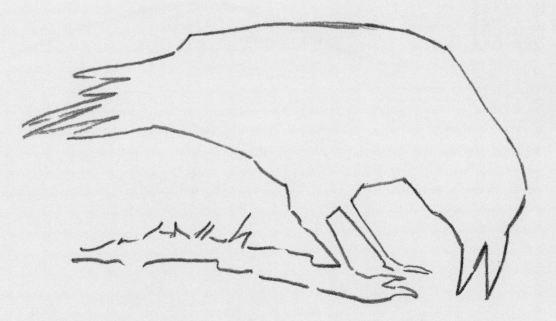

Gesture Sketches

GETTING **FREE** AND **FLUID** WITH GESTURE SKETCHES

The goal of gesture sketching is not to portray the subject realistically, but rather to capture the essence of the subject and what it is doing. Gesture sketches should be very un-inhibited and fluid. Lines are re-stated frequently as the artist seeks to lend a sense of motion or grace to the sketch.

Making a series of gesture sketches can help you get the feel of the subject in a non-threatening manner. Gesture sketches are the stretching exercises that help you loosen up and prepare yourself before drawing the subject in a more realistic manner. Doing them on scratch paper will help you take them less seriously.

MAKING A **GESTURE SKETCH**

Begin by studying your subject. Look for long, curving lines that depict the pose or action of the subject. If it is a human or animal, a good place to find these action lines may be along the spine, from the head or neck and continuing to the rump or down the leg. Legs and arms can readily suggest long, fluid lines, especially if they are holding extended objects such as golf clubs or baseball bats. The limbs of long-legged animals are very graceful and provide wonderful action lines. Inanimate objects with graceful, curving edges can also make lovely gesture sketches. Think of the upward-sweeping tree limb, the fluid curve of a pitcher or the arch of a cathedral door. The action lines for the sketches on these two pages are marked with purple arrows.

Set down the main action line. Make it loose and sweeping. This is the starting point for the rest of the draw-ing. Now sketch. Move quickly. Don't give yourself time to form preconceived ideas. Glance at a small area of your subject, sketch it and return to your subject for another quick look. Continue your sketch until you come to another action line. Draw the new action line in one freely-rendered motion and develop the rest of the drawing around it. If it is out of proportion, don't worry about it! If the sketch is loose and fluid, you have succeeded.

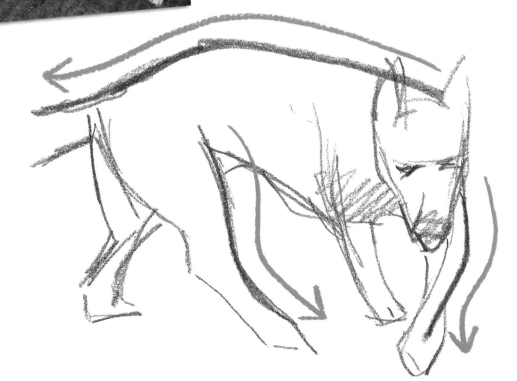

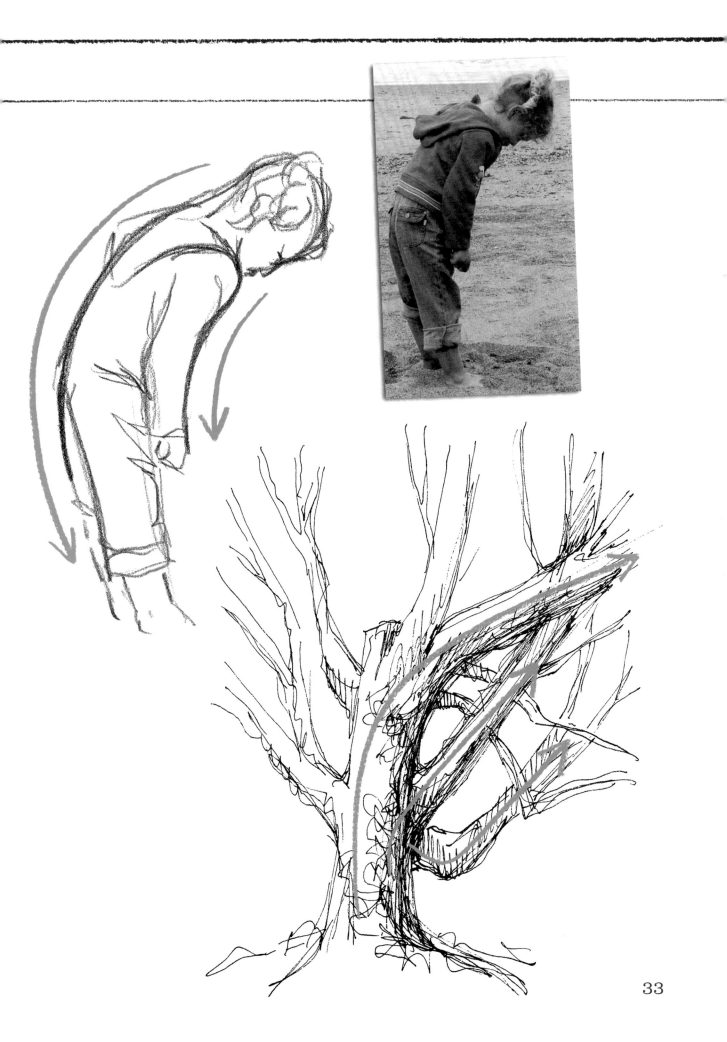

Positive and Negative Shapes

Positive shapes are the areas on the drawing surface that form the subject matter. They may be suggested by outlines, solid tonal areas, texture marks or value changes. Cast shadows and soft background images are also considered as positive shapes. In reverse value drawings where the subject matter is light and the background is gray or black, the light areas are the positive shapes.

Negative shapes are the areas not taken up by the depiction of subject matter. In a gray scale drawing they may be paper white, gray or solid black. Note the positive and negative areas marked with purple arrows in the drawing of the wheel barrow and the pitcher.

Trapped negative shapes are those areas that are completely surrounded by subject matter. Notice in the drawing of the bench that when trapped negative areas are drawn as separate shapes, they look odd, as if they might not fit back into place. This is because we are not used to seeing them as distinct shapes, but rather as empty areas. However, negative shapes, both trapped and open, are just as important to the drawing as positive areas. If a negative space in a drawing appears to be off, it is a good indication that the positive shapes surrounding it are drawn out of proportion.

Positive shapes make up the busy portions of the drawing. Negative shapes provide solid toned areas which are restful to the eyes. When positive shapes overwhelm the drawing, it becomes cluttered and confusing. When there is an overabundance of negative space the drawing may appear insignificant. Maintaining a good balance of interesting positive and negative shapes is important to the effectiveness of the finished drawing. The drawing of the bonsai tree shows a good balance of positive and negative shapes.

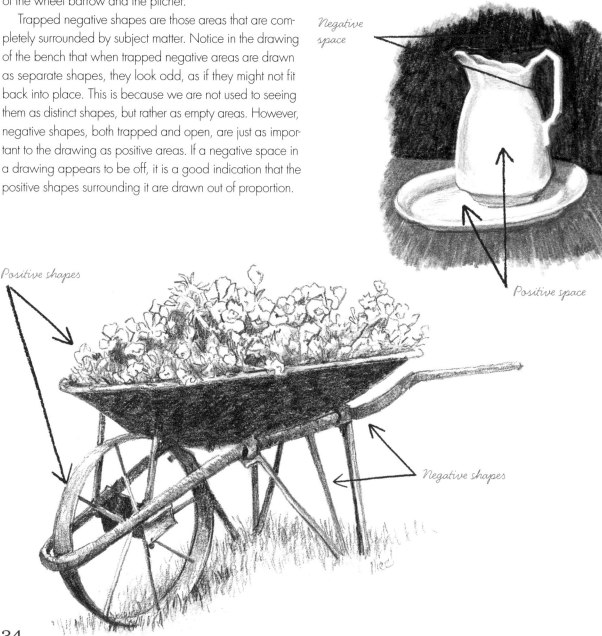

Negative space

Positive space

Positive shapes

Negative shapes

34

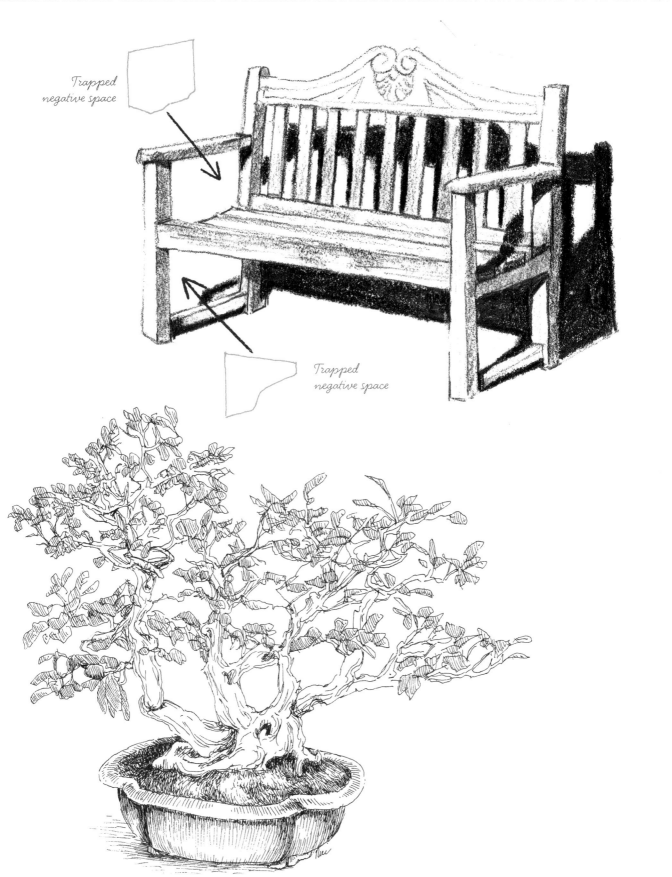

Trapped negative space

Trapped negative space

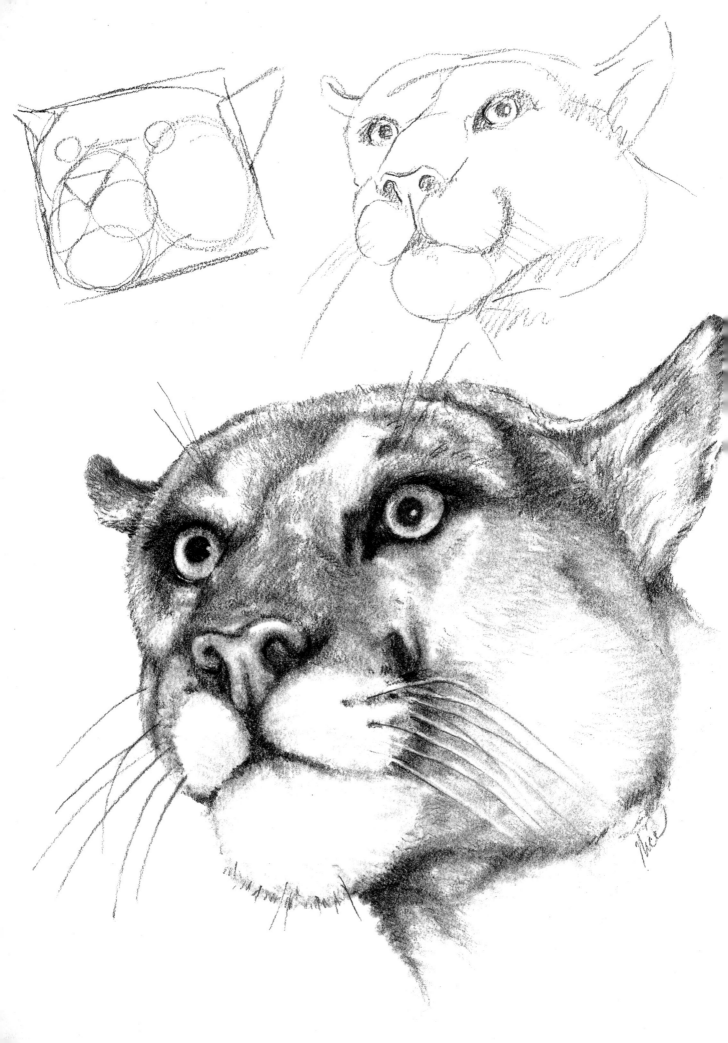

3 Using Shapes as Building Blocks

Drawing geometric shapes is easier than drawing recognizable forms. You are less likely to be overwhelmed by drawing a group of rectangles, ovals and triangles than by drawing a vase of flowers, a building or an animal. Most of us are very familiar with basic geometric shapes: squares, rectangles, triangles, circles, ovals (egg shapes) and ellipses. Our preconceived ideas of how they should look are fairly accurate. If we can find those shapes within the contours of the subject we are drawing and set them down on the drawing surface with some accuracy, considering comparable sizes and positions, we will have the basic form of the subject in place. This roughed-in form is the starting point. Once you have a form on paper, it can be developed and refined. Study the drawing of the cougar on the facing page. Can you see the basic geometric shapes in the face?

Another way of getting a basic form set down on paper is to make a contour drawing. This method is popular with beginning artists because you can depict the most interesting part or the easiest part of the drawing first and add the rest as you come to it. However, there are several drawbacks to creating a

preliminary drawing in this manner. Let's say you are drawing a cat. The most interesting part of the cat is the head and it is the usual starting point. It's tempting to add the facial details before you draw in the rest of the body. Adding details before getting the complete form in place is a waste of time if that part of the figure needs to be repositioned or adjusted in size.

The second problem in contour-style preliminary drawings is that it's hard to keep track of all the parts when you're concentrating on one area at a time. Remember the blind contour drawings in Chapter 2? They captured some good angles and contours, but the various parts did not correspond well with each other. This tends to happen in all preliminary contour drawings, even when the work is not blind.

Finally, if you are creating the outline of a cat, preconceived ideas are going to be telling you how a cat should look throughout the whole drawing process. In this chapter you will become better acquainted with the use of geometric shapes to set down preliminary forms in a quick, more precise manner.

Cougar
Drawn with 2B, 4B and HB pencils and a blending stump for softening the fur.

The Basic Geometric Shapes

We all know them, but it doesn't hurt to review the basic geometric shapes. The shapes below were drawn first using a template, then each was sketched freehand with a pencil. Practice these shapes whenever you can.

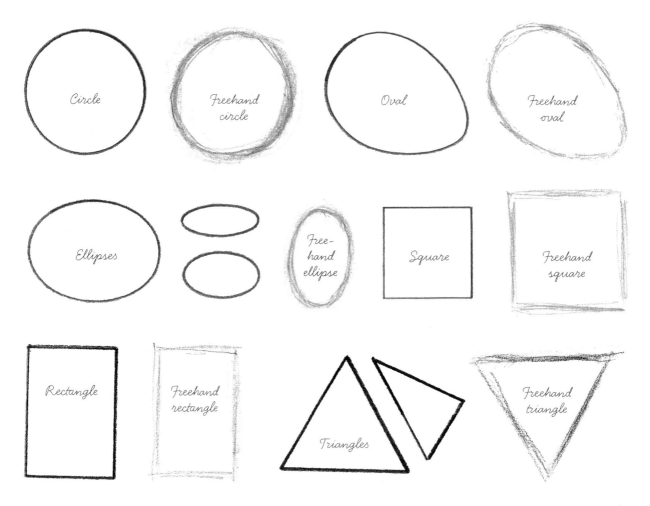

Two or more simple geometric shapes can be lined up or overlapped to suggest more complicated shapes.

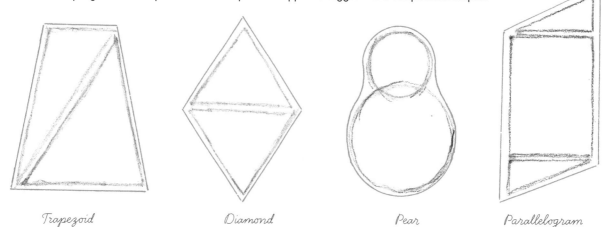

Trapezoid Diamond Pear Parallelogram

WHERE TO **START**

Studying the subject is always the place to start. Look at the overall contour of the subject. Sometimes there is a simple geometric shape that suggests its outer configuration. The daylily in the photo is a good example of this. The three inner petals form a triangle. The back petals form a second triangle. Roughing in these two shapes, as shown below in Figure 1, creates a framework in which to sketch the flower. As you can see, some of the petal shapes will remain within the frame and others will extend over the edges. The guidelines of the triangle help to keep the petals in proportion to each other.

This first step is rough, with many re-stated lines. Don't be overly concerned about perfection during this preliminary stage; concentrate on gaining a better understanding of the subject. I usually work very lightly in pencil right on the drawing surface. However, the preliminary drawing may be worked on scratch paper until a simple outline is developed (Figure 2), then transferred to the drawing paper.

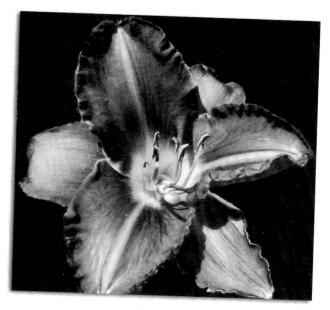

Daylily reference photo.

Figure 1

Figure 2

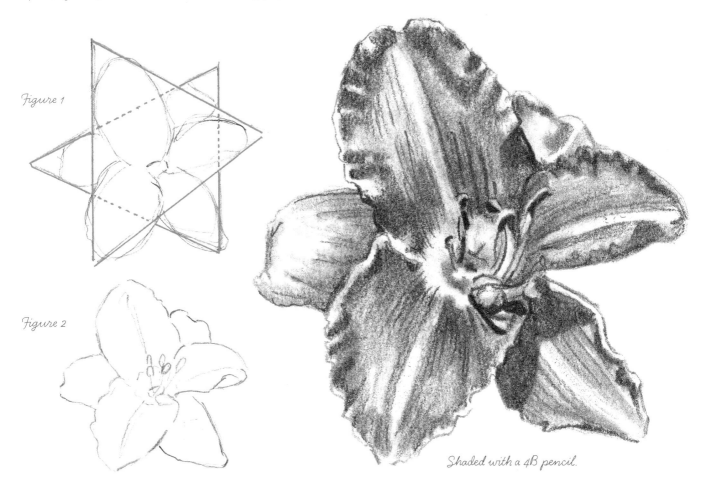

Shaded with a 4B pencil.

39

SURROUNDING THE **SUBJECT**

Flowers, leaves, shrubs and even trees seen at a distance are the most likely subjects to have outer perimeter shapes. Study the photograph of the petunia blossoms. What geometric shape would you use to suggest the outer perimeter of each flower? The blossom on the left would fit nicely into a rectangle or an oval. A triangle or a narrow ellipse could be used to suggest the flared petal portion of the blossom on the right. There is no one correct shape to use, as each artist may see the subject a little differently.

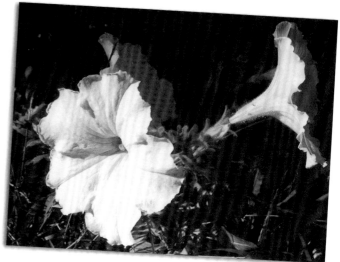

Photo of petunias.

Photo of poppy.

The uneven edges of the poppy could be difficult to draw, but enclosing them in a circular perimeter tames them down. The perimeter provides an outer reference point that prevents the frilly exterior from becoming lop-sided. Inner perimeters are helpful for the same reason.

Finished drawing with rubbed-pencil shading.

The outer edge of foliage-covered tree branches usually fits quite nicely into one of the geometric shapes. Here are some examples.

Photo of spruce tree.

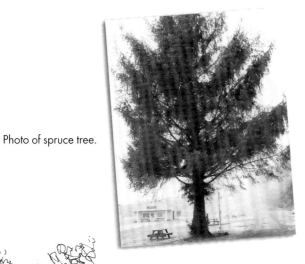

The branches of this spruce tree form an oval. The outer perimeter helped me draw the limbs the proper length.

This young plum tree has a broad elliptical shape. The clumps of foliage were scribbled in using a .35mm Rapidograph pen. It's important to maintain open patches between the leafy areas.

Apple tree *Mature pine tree* *Poplar* *Sugar maple*

Main Body Shapes

Not all subjects have a conveniently shaped geometric exterior. In fact, most of them don't, especially animals and people. Arms, legs and heads are hard to combine into one simple outer shape. When the subject is made up of a combination of many overlapping forms, start with the largest shape. This will usually be the trunk of an animal or human. Consider it the center of your drawing and make sure all of the shapes added to it correspond in size and placement.

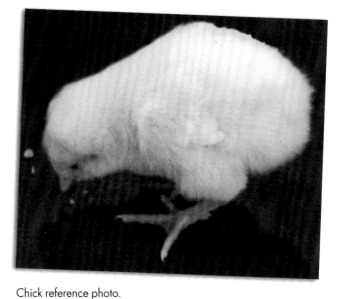

Chick reference photo.

The body of the chick is egg shaped, with the smaller end of the oval facing towards the tail.

The head is also an oval turned upward. Two of its widths would fit into the body shape if placed side by side. A line drawn from the crown of the head to the crest of the back forms the angle of the upper neck. It should match the neck angle in the photo. If any of these shapes or angles are out of proportion, it's a good time to make corrections.

Shapes representing the beak, wing, leg and foot are added and compared to the reference photo to check comparative size and correct placement. Lines can be restated instead of erased to prevent interruption in the flow of the drawing.

The resulting sketch is finished right over the top of the preliminary work. If the lines suggesting the primary shapes are kept light, they tend to be absorbed into the drawing.

The oval curve of the rib cage is fairly easy to spot. I often set it down first. In the drawing of the giraffe, the oval is slanted upward slightly to match the angle of the back. If the animal is standing sideways to the viewer, a rectangle may encompass the trunk area, giving the artist an overall shape to start with. Note the drawing of the zebra: the corners of the rectangle that stick out beyond the trunk can be erased later if they are too distracting in the finished sketch.

An oval works nicely to suggest the whole trunk of this chubby bear.

The trunk of the zebra fits nicely into a rectangle.

Bones and Muscles

Knowing something of the inside structure of an animal will help you see the outside form more clearly. The bones, covered in muscle and flesh, form the outer contours. Depicting the shadows cast by these raised areas will keep the animal from looking flat. Study the skeletal structures of the cat, dog and horse shown below. You will see quite a few similarities. In fact, most land animals including man have similar bones and bone arrangements. The difference between the structure of one animal and the next is not so much in bone placement, but in their size and shape. Just for fun, the bones in the dog skeleton are labeled with their equivalent human feature.

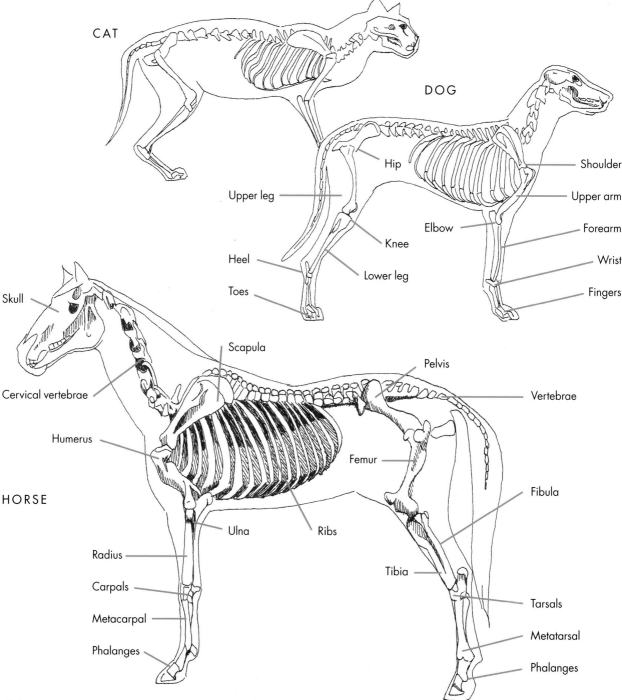

CAT

DOG

Hip
Shoulder
Upper leg
Upper arm
Elbow
Forearm
Knee
Wrist
Heel
Lower leg
Fingers
Toes

Skull
Scapula
Pelvis
Cervical vertebrae
Vertebrae
Humerus
Femur
Fibula
HORSE
Ulna
Ribs
Tibia
Radius
Carpals
Tarsals
Metacarpal
Metatarsal
Phalanges
Phalanges

ROUGH DRAWING OF **HORSE**

To form a rough drawing of this horse, I began by setting down a rectangle to represent the trunk (Figure 1). By studying the photo, I determined that this rectangle needed to be twice as wide as it is tall. I added a large oval to the chest side of the rectangle to represent the curve of the rib cage.

Study the shoulder and hip area of the horse. Do you see raised areas outlined by light and shadow? The scapula and humerus, cushioned with muscle and flesh, form a chevron shape pointing to the front of the horse, while the padded pelvis and femur form a chevron that points toward the tail. These elevated areas can be suggested by two overlapping ellipses (Figure 2).

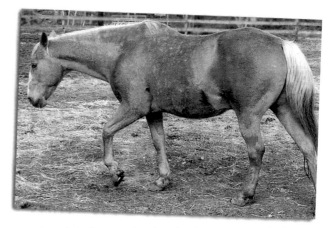

Even though the horse in this photo has his winter coat, the bone structure and muscle masses are evident beneath it.

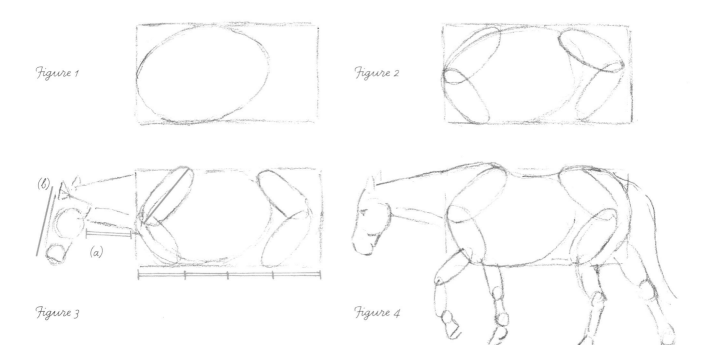

Figure 1

Figure 2

Figure 3

Figure 4

With the trunk roughed in, the head and neck need to be added (Figure 3). By comparing the length of the space between the cheek and the point of the shoulder (a) to the length of the trunk, I gained an idea of how long the neck needed to be. The head is about the same length (b) as the ellipse representing the scapula. It can be suggested with a long trapezoid shape and two circles to round out the cheek and muzzle.

Figure 4 shows how well ellipses and circles work to rough in the legs. Comparing the length of the legs to the height of the trunk helped me to keep them in the right proportion.

With the foundation shapes in place, the horse drawing is ready for refinement.

45

Basic Shapes in the Human Figure

A trapezoid shape, with the wide part at the top, works well to suggest the upper portion of the human trunk from the shoulders to the waist. A shorter trapezoid, turned up-side down, can be used to rough in the area of the trunk from the waist to the crotch. In the average person, the crotch is the mid-point of the figure. The arms and hands hang down to the mid-point or slightly past.

The head is roughed in as an oval shape. The average adolescent or adult human is approximately six head-and-neck-lengths high (see diagram at right). The two trapezoid shapes representing the trunk are usually as long as two head-and-neck sections. The upper legs extend up into the lower trunk to connect with the pelvis, making the area taken up by the legs and feet approximately the same length as three-and-a-half head-and-neck sections.

The arms and legs can be suggested with long, narrow ellipses. Circles work well for the knee joints, and ovals or long trapezoid shapes can be used to rough in the hands and feet.

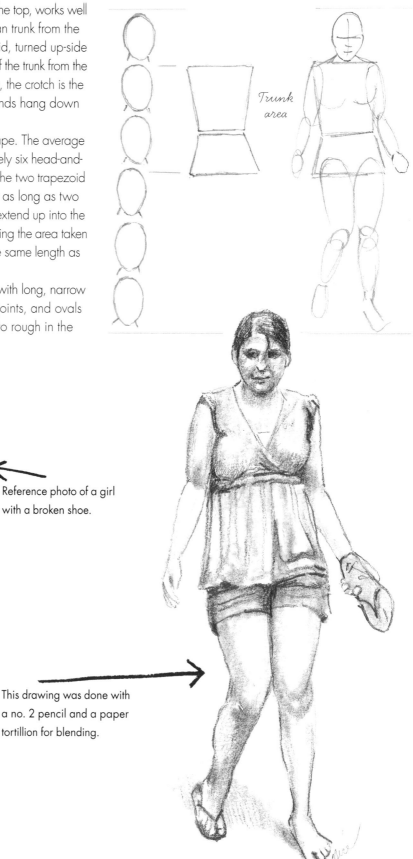

Trunk area

Reference photo of a girl with a broken shoe.

This drawing was done with a no. 2 pencil and a paper tortillion for blending.

46

The best subjects are those which are familiar. The step-by-step pencil study shown at bottom is a drawing of my Dad. It was sketched from a photo since the subject is in motion.

Girl sitting on a driftwood log, drawn with a 2B pencil.

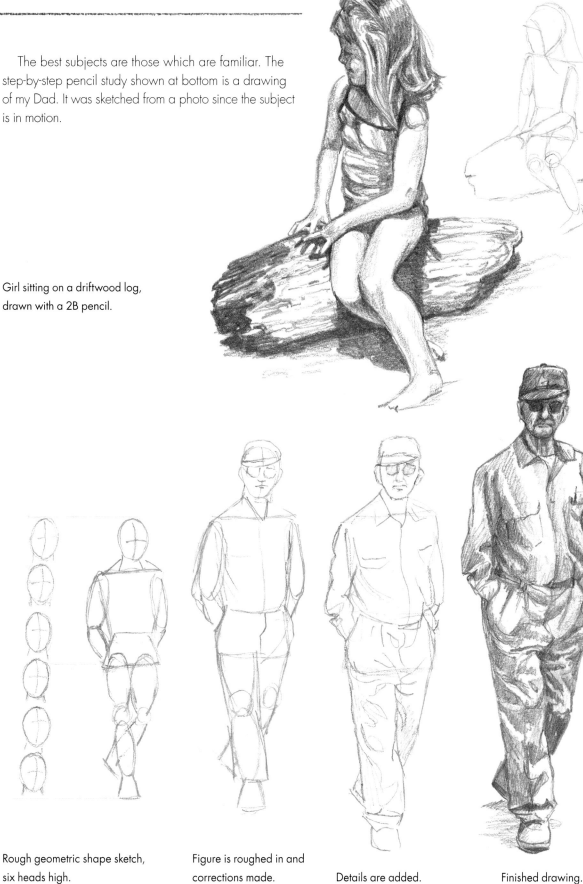

Rough geometric shape sketch, six heads high.

Figure is roughed in and corrections made.

Details are added.

Finished drawing.

SKETCHING **YOUNG CHILDREN**

Young children have significantly different body proportions than those of school-age children and adults. Their heads are large compared to the rest of their body, taking up approximately one-fourth of the length of the frame, neck included. Note the diagrams on the right. As the child grows, the legs lengthen until the head and neck take up only about a sixth of the height at age seven.

As you refine your preliminary sketch, keep in mind that a toddler will have more "baby fat" than the average-weight school-age child. Add a little more roundness to the toddler's contour.

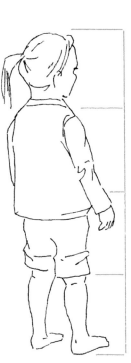

A 3-year-old is four head-lengths tall, with the mid-point near the waist.

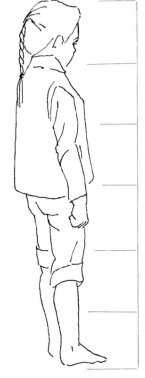

A 7-year-old is six head-lengths tall, with the mid-point below the waist.

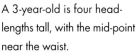

Rounded contours

This upset 2-year-old boy is running to mother. Although his legs and feet take up less than half the length of his body, he can move right along. He was sketched with a 2B pencil.

This line and shadow sketch of a boy pushing his toy truck was drawn using a .25 mm technical pen.

48

BALANCING THE FIGURE

When you think of all of the positions we humans can find ourselves in and how easily we can become unbalanced, it's a wonder we can stay upright most of the time. However, drawing a human figure in proper balance is not that hard. To find where the weight-bearing area needs to be, simply draw a plumb line from the center of the base of the neck to the ground or to the first object you may encounter like a chair, a rock or the person's own foot. The end of the plumb line indicates where the majority of the person's weight will rest.

To be in balance, there needs to be a foot, hand or sturdy object beneath this spot, or two or more limbs straddling it. Drama can be added to the drawing by deliberately drawing the figure out of balance and having it supported by leaning against or pulling against another object. Study the drawing of the man pulling on the sapling. His center of balance is behind his left foot. If the sapling should suddenly snap, he would tumble backwards.

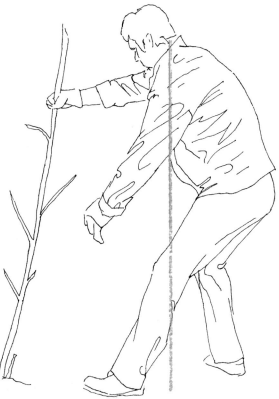

• *Center of balance*

This little boy, intently watching his top spin, would fall forward if his little rump didn't act as a counterbalance to the forward position of his head and neck.

In this sketch of a boy riding a boogie board, the majority of his weight is on his back (right) leg and foot. His outstretched arms help him maintain his precarious position.

TURNING CYLINDERS INTO **FINGERS**

Hands are considered one of the more difficult parts of the human anatomy to draw. With four fingers and a thumb, all capable of bending at several different angles, it can be overwhelming. Yet if you think of the fingers as a string of three cylinders, loosely attached at the joints, drawing a hand becomes a little easier.

The cylinder is a three-dimensional form. It can be tube-shaped (hollow) or rod-shaped (solid). The fact that it is rounded instead of flat makes it perfect to represent a section of a finger or thumb. A cylinder, viewed from the side, will have an ellipse shape at one end and a matching curve outward on the opposite end. The corner edges of the cylinder are rounded, not pointed or squared off.

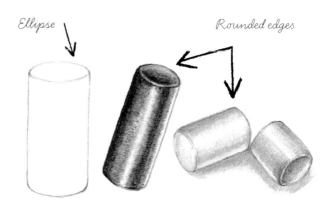

Ellipse *Rounded edges*

Side views of cylinders shown at different angles are a good starting point for understanding finger shapes.

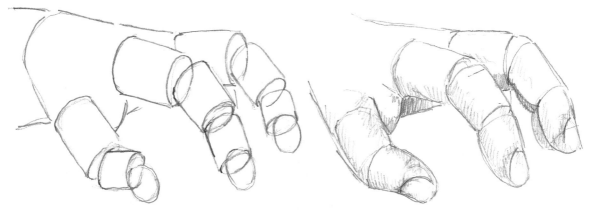

Begin with a roughed-in sketch of a hand, using cylinders to represent the sections of the thumb and fingers.

As the thumb and fingers are sketched in and refined, the cylinder shapes can be erased.

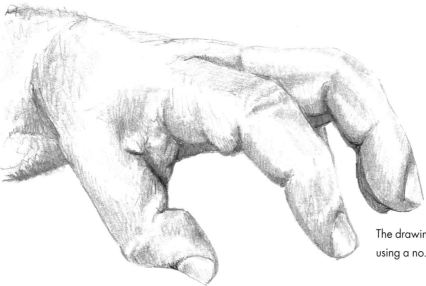

The drawing of the hand is completed using a no. 2 pencil.

50

FORESHORTENING

When a cylinder is viewed from the rounded end, the length of the tube or rod will not be distinctly apparent. Due to the laws of perspective, the end of the cylinder will look rounder and the side shorter, as the end is turned to face us more directly, as shown at right. This phenomenon is called *foreshortening*.

Fingers also present a foreshortened perspective when they are viewed from the finger tips. Preconceived ideas will tell us that we need to somehow draw the length of the digit, no matter how it actually appears to the eye. To avoid this conflict, practice drawing foreshortened cylinders and use them to construct foreshortened fingers.

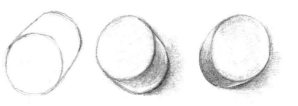

Foreshortened cylinders can represent fingers viewed from the tips.

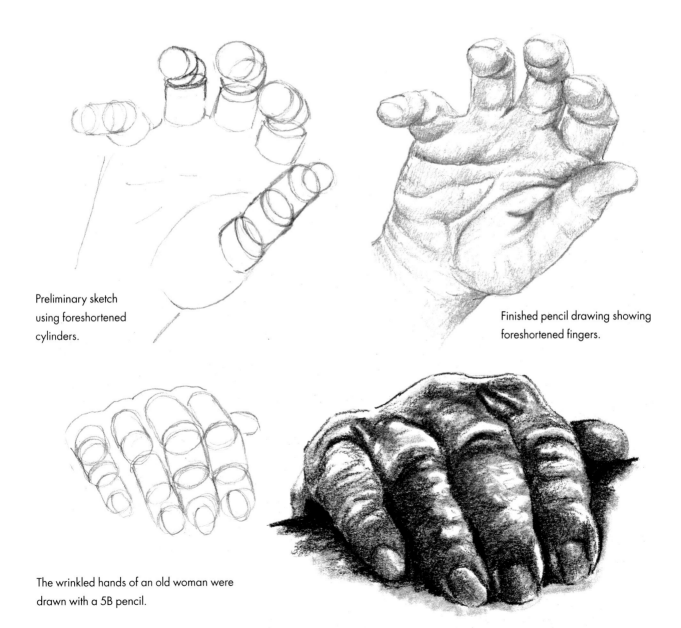

Preliminary sketch using foreshortened cylinders.

Finished pencil drawing showing foreshortened fingers.

The wrinkled hands of an old woman were drawn with a 5B pencil.

Using Elliptical Shapes

Simply put, an ellipse is a foreshortened circle, a circle viewed from somewhere along its outer circumference instead of straight on. As the rim of the circle is turned toward us to a greater degree, the ellipse becomes narrower. Study the wheels in the ink drawing of the wagon below. The smaller wheel, which is turned more directly toward the viewer, has a much narrower elliptical shape. Notice that the hub of the wheel seems to be located closer to the back edge of the rim than the front. In foreshortened objects, the forward section always appears larger than does the aft section.

To check the curves of an ellipse sketched freehand, surround it with a rectangular shape of the proper proportions to fit snugly against it. The edges of the ellipse should touch the middle of each wall of the rectangle in a gently curving manner, as shown at right. Divide the rectangle into fourths and diagonally from corner to corner. A tracing paper overlay can be used if you don't want to mark the drawing surface. These guidelines will help the eye to make comparisons from one area of the ellipse to the next. The curves in the opposite corners should be mirror images of each other.

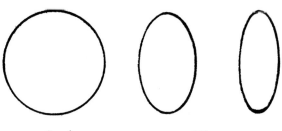

Circle Ellipses

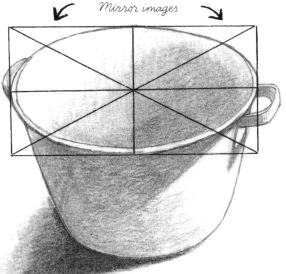

Mirror images

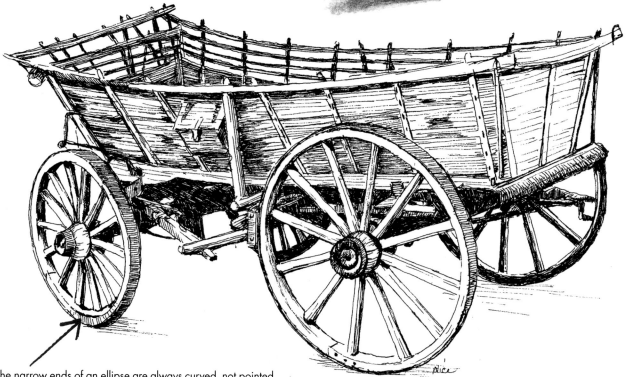

The narrow ends of an ellipse are always curved, not pointed.

PRACTICE **EXERCISE**

Draw several objects that contain elliptical shapes. Work with a light touch, re-stating the lines to maintain your concentration on the shapes. When you have formed a symmetrical ellipse, fill in the lines a little heavier. In most cases, the lines that look correct to your eye are the ones to go with. Check your work using a divided rectangle.

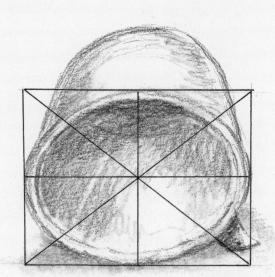

An antique wringer washing machine (pen and ink)

Not perfect, but good enough for a sketch

Wooden planter (charcoal stick)

53

Drawing Negative Shapes

When the object you are studying has a lot of open, see-through spaces within it, drawing the negative spaces first can give you a new understanding of the subject.

Consider the gate in the reference photo. Situated between the boards are a series of dark open spaces. These trapped, negative areas have definite shapes that can be recorded on paper. The big difference between drawing negative spaces and solid boards is that our minds have fewer preconceived ideas of what open spaces should look like. Therefore we are free to draw what we actually see. That in itself is a major plus.

As you study the photo, note how the negative spaces line up with each other. If negative spaces are out of alignment, the positive parts of the subject will be also.

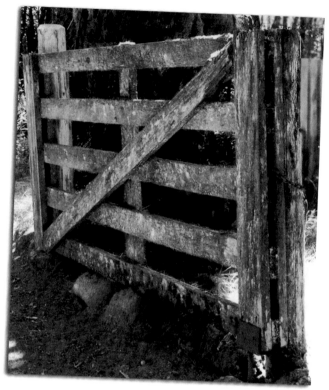

Reference photo of an old wooden gate.

Start sketching the gate by setting down the top row of trapped spaces. They are roughly rectangular in shape, with the diagonal brace board cutting across the space on the right. Lightly sketching in the diagonal board helps you achieve better alignment of the negative spaces.

While the top row of trapped spaces is slanted slightly upward, notice that each row beneath it moves at a steeper angle downward. Also, the right side of each rectangular space is slightly wider than the left side. This has to do with perspective and will be explained in more detail in Chapter 6. As you proceed to draw in the trapped negative spaces, the gate begins to take shape.

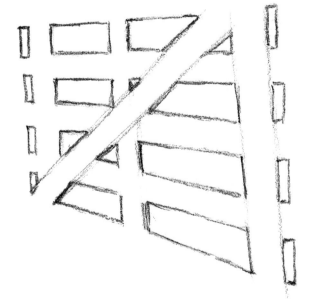

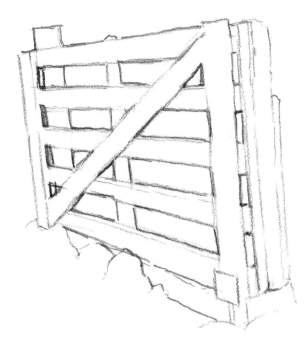

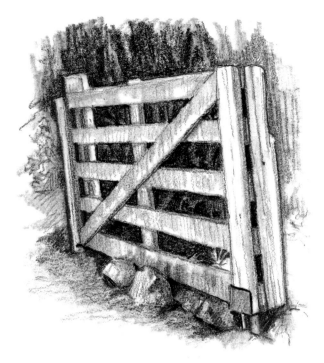

The negative areas surrounding the gate are drawn in, along with some of the details of the gate itself.

Shade the negative spaces using an Ebony Design pencil and add texture to the rocks and gate.

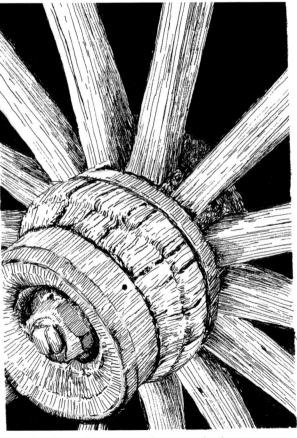

By drawing and filling in the negative spaces and adding a few of the darkest shadows, this wagon wheel has already begun to take shape.

Pen and ink lines add contour and texture to the drawing.

Combining Shapes

When two or more objects overlap each other and share the same value on the gray scale, edges can be lost. This can also happen when an object and a shadow shape run together, providing they share similar value tones. Study the reference photo at right. The old iron gate is seen in heavy shadow and some of its parts are obscure. Directly behind the gate are tree branches of the same dark value. Separating the gate from the branches would not be too hard, but drawing the individual leaves on the silhouetted limbs would require a lot of guesswork. It is much easier to combine all of the dark areas and draw them as if they were one unit. A quick felt-tip pen sketch will tell you if the combined design will work (Figure A). Ask yourself these questions:

1 Are the individual elements still recognizable in the combined format?

2 Does the combination improve the overall design?

3 Does combining the elements make the drawing easier to handle?

The answer should be yes to all three questions. If not, the alternative would be to change the value of one of the overlapping elements.

Just for fun, I made a second felt-tip pen sketch of the gate in which I drew and filled in the negative spaces (Figure B). This gave me an idea of how the scene would look if the light and shadow areas were reversed.

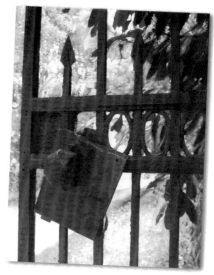

The finished gate drawing (opposite page) was completed using 7B and 9B pencils in the dark areas and a 2B pencil in the background. Although there is some tonal variance between the gate and branches, the overall effect is that of shadowy unity.

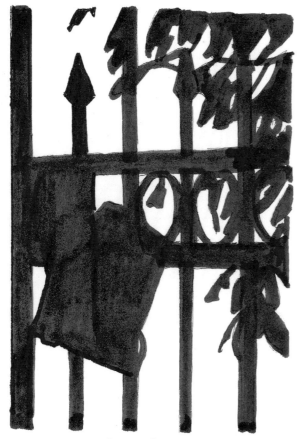

Figure A

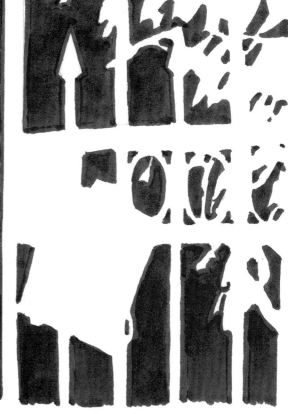

Figure B

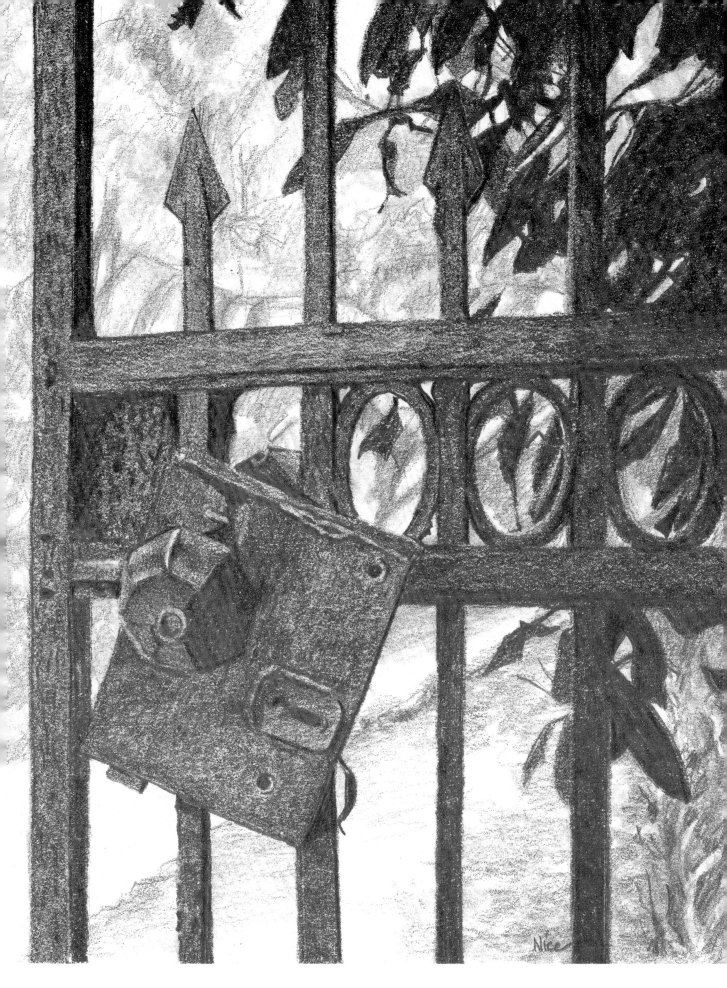

Thoughts to Keep in Mind

1 Simple geometric shapes can be used as building blocks to help you draw more complicated subjects.

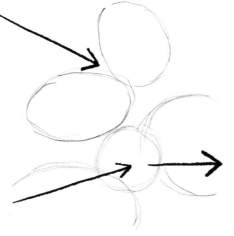

2 Surrounding a subject with an overall shape can help keep the separate parts from becoming out of proportion to each other.

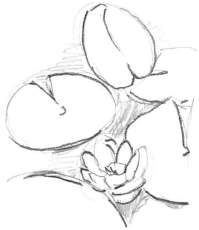

3 Start each animal or human drawing by sketching in the largest shape, usually the trunk.

Water Lily sketch

4 In sketchy drawings, re-stating lines rather than using the eraser will keep the creative process from being interrupted.

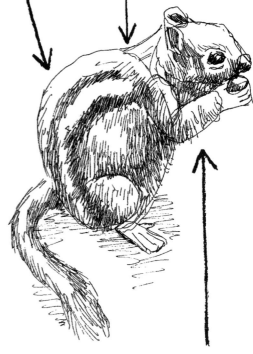

5 Ovals and ellipses can be used to indicate bone and muscle masses in animal sketches.

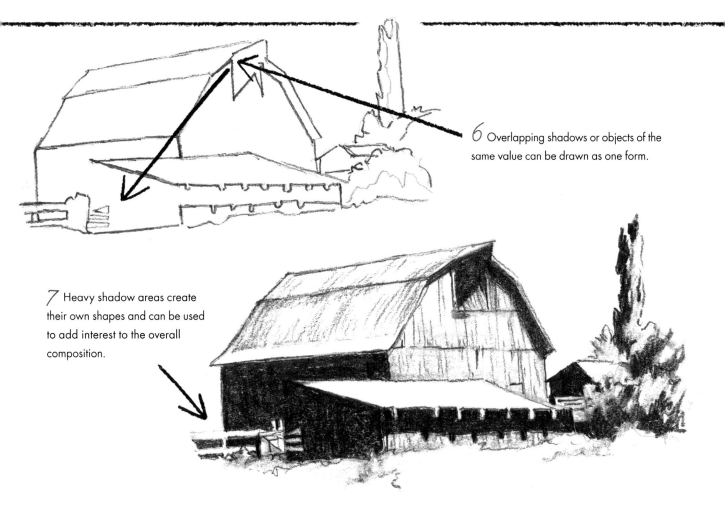

6 Overlapping shadows or objects of the same value can be drawn as one form.

7 Heavy shadow areas create their own shapes and can be used to add interest to the overall composition.

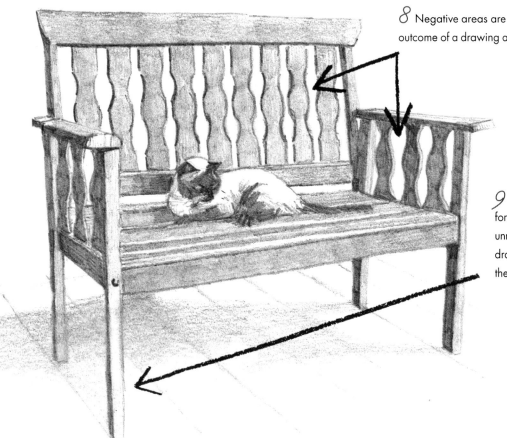

8 Negative areas are just as important to the outcome of a drawing as the positive ones.

9 The forward sections of foreshortened objects appear unnaturally large. Nonetheless, draw them as they appear to the eye.

59

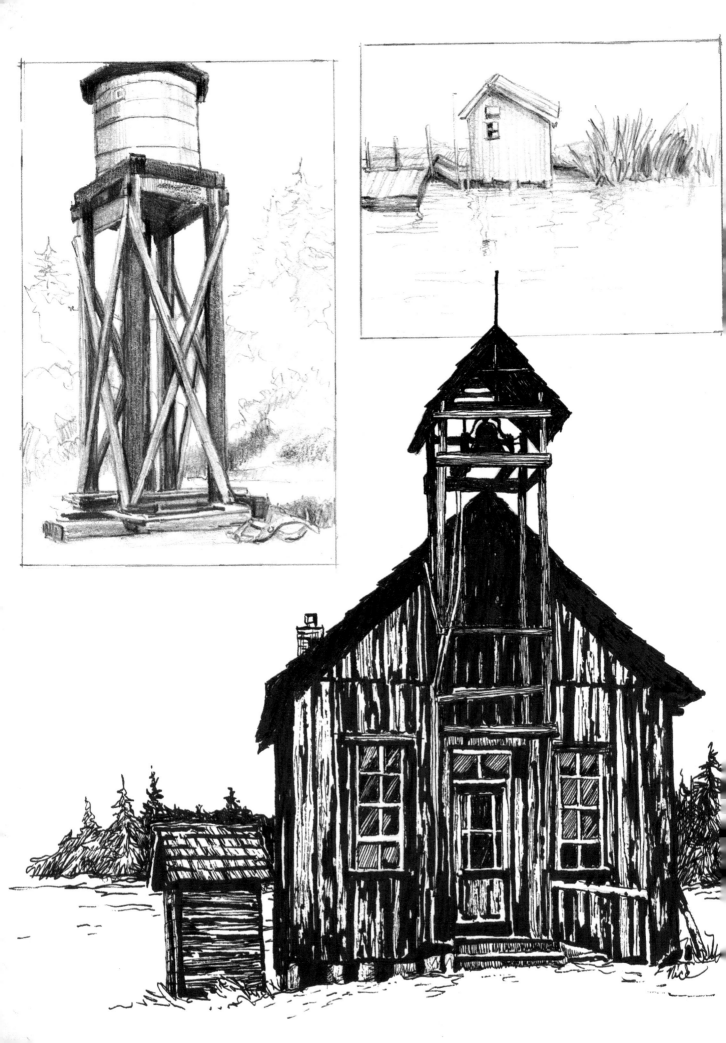

4 Comparative Thinking

Have you ever concentrated so hard on getting a challenging part of your drawing completed that you forgot to keep track of the overall picture and ran out of room? Did you end up sacrificing the top of the subject's head or cutting off part of his legs to make him fit? Did your still life arrangement ever look like a weed trimmer had whacked off the top because you drew the vase too large and didn't leave room for the flowers? It can happen so easily!

Study the pencil sketch of the water tower on the facing page (top left). The support posts and braces were tricky to draw and took a lot of time and effort. They look pretty good, but the top of the tower ended up out of the scene. It wasn't planned that way—the tower just seemed to grow taller the more I fussed with it.

Almost as frustrating as the drawings that grow too large are the subjects that are sketched so small that they are overwhelmed by the empty space surrounding them. The little fishing shack on the facing page (top right) is so small that it looks like part of the background rather than the center of interest. Actually, it was supposed to be bigger; it just didn't come out that way.

Fitting the subject onto the drawing surface so that it fills the area intended for it, no more and no less, can be challenging. In fact, many an eraser has been worn down trying to achieve a nice fit. Yet with a little pre-planning and some size comparisons, you can learn to maintain proportional control over your drawings. The ink drawing of the rustic old western schoolhouse on the facing page did not fit neatly into its corner space by accident. I marked the area I wanted it to take up and scaled it into place. While I was at it, I used comparative thinking to make sure that all the parts of the building remained in proportion to each other. The best part is that it's not hard; you merely have to open your eyes to a new way of looking at your subject. To find out how it works, turn the page.

FINDING THE **MID-POINT** IN THE **HEIGHT** OF A SUBJECT

The subject of this demonstration is the little reference sketch of the lighthouse at right. The objective is to draw it to scale on a larger piece of paper and still maintain the fun and freedom of doing it freehand.

The first step in the process is to determine where the mid-point is in the height of the lighthouse. You might ask, "Why not use a ruler and be done with it?" That's a good question, with several answers.

1 If you learn to depend on a ruler, then you will have to have one with you whenever you go out to sketch.

2 Working with a ruler and the division of numbers is more of an architectural endeavor than a sketching process. It can detract from the fun and creativity of the drawing.

3 But most important, finding the mid-point by sight and instinct, and then confirming your guess, will train your mind and eye to make accurate comparisons.

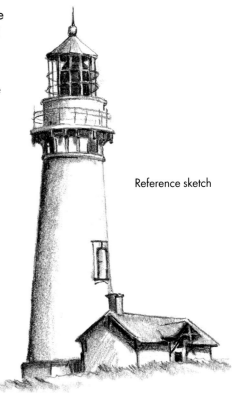

Reference sketch

1 Using the reference sketch above as your subject, take a guess at where the mid-point is in the height of the lighthouse and mark it with a light pencil dot. Hold a pencil or any straight stick-like object so it is vertical and the top is even with the top of the lighthouse. Move your thumbnail so it is even with your perceived mid-point, where you placed your pencil dot.

Some mid-points are harder to determine than others due to the shape of the object you are working with. In some instances, it may be easier to mark the total height of the object with your thumbnail on the pencil and guess the half-way point of the designated length of the pencil. However you choose to do it, training your eye to determine mid-points is a valuable skill worth developing.

② *Without moving your thumbnail, slide the pencil down so the top of it is lined up with the mid-point mark. Check and see what your thumbnail is lined up with. If it is even with the base of the lighthouse, your mid-point guess was correct! If your thumbnail is above the base of the lighthouse, then your mid-point guess was a little high. If your thumbnail rests below the base, then your mid-point mark is too low.*

③ *Once the lighthouse has been divided into two equal upper and lower sections, draw straight horizontal lines across the top, middle and bottom. Does it appear that the lower half is longer? That's an optical illusion! Measure with a ruler and you'll see that both sections are indeed equal. Now you can begin drawing the lighthouse to scale on a new drawing surface.*

Scaling the Subject to Fit the Paper

When the subject is very tall, like the lighthouse, it is beneficial to divide it into fourths as shown in the sketch at right. This gives the eye more reference points. This process is similar to the grid method of rescaling the size of a drawing, but is faster and far less rigid. To divide the subject into four sections, divide it in half first and then re-divide the top and bottom sections.

Top

Top quarter

Mid-point

Bottom quarter

Bottom

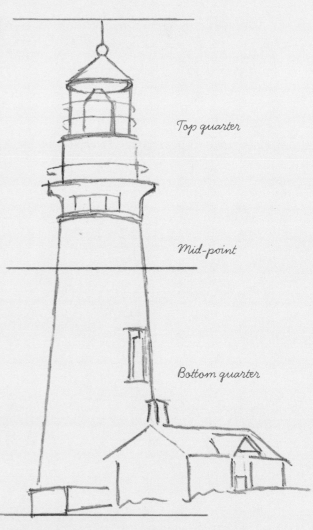

Top quarter

Mid-point

Bottom quarter

First, on your drawing paper, decide how much space you want the subject to take up. It can be scaled either up or down using this method. Mark the top and bottom with a light pencil line. The example at left is marked with double lines at top and bottom just to keep better track of what's what. Find the mid-point and mark it with a pencil line. Do the same with the quarter marks if they are being used.

Now it's time to make some visual comparisons between the divided subject and the divided drawing surface. Keep in mind that each section on the paper can only contain its allotted amount of the drawing. Adding more or less to each section will throw the overall drawing out of proportion.

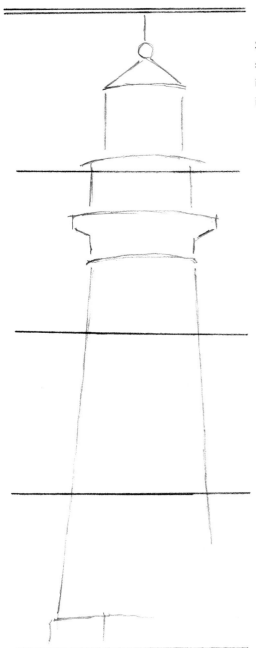

Second, begin blocking in the lighthouse using simple geometric shapes and re-stated lines, as shown at left. Work lightly, keeping a constant vigil on what belongs in each section. If you sketch the contents of a section too large or too small, correct it right away. It's much easier to redraw one section than the whole drawing.

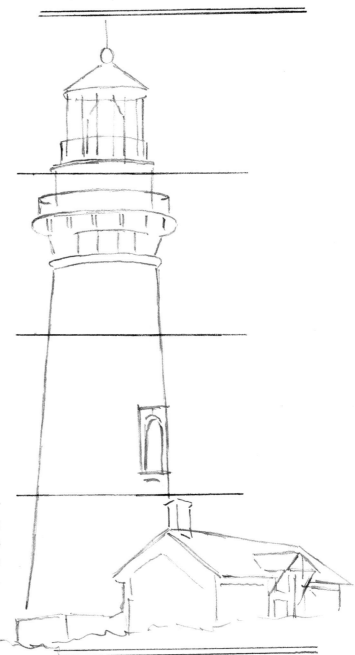

Finally, once you have all the parts blocked into their proper location and everything actually fitting together, the drawing can be refined and details added. This comparison process will become a spontaneous part of your drawing skills as you practice and develop it.

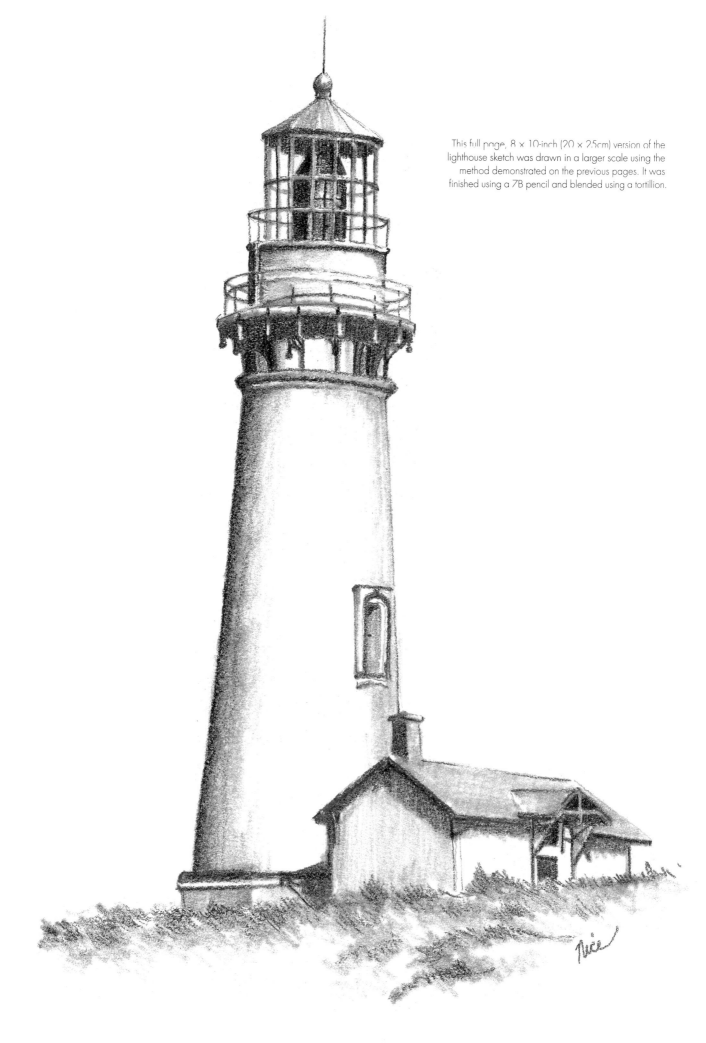

This full page, 8 × 10-inch (20 × 25cm) version of the lighthouse sketch was drawn in a larger scale using the method demonstrated on the previous pages. It was finished using a 7B pencil and blended using a tortillion.

Working from a Photograph

When working from a photograph, draw division lines beside it on a piece of scratch paper so the photo is not damaged. Another option is to draw grid lines on a piece of clear acetate and lay it on top of the photo. This pre-made set of grid lines can be used over and over again.

For field studies or when working from a live setup, sight in the subject behind your pencil (or your thumb if you wish to look very artsy) and estimate where the mid-point is. This *plein air* method is less accurate, but still helpful in gaining a better understanding of the height of the subject.

Reference photo of a rooster, with division lines drawn beside it.

Simple shapes are used to block the rooster into place.

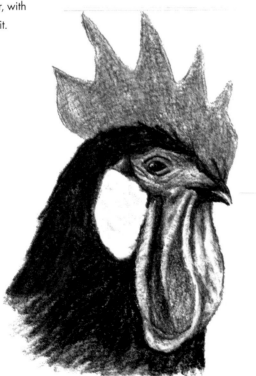

The completed rooster drawing, finished using a charcoal pencil.

demonstration

FINDING THE **MID-POINT** IN THE **LENGTH** OF A SUBJECT

Finding the half-way point in the length of the subject is just as important as documenting the mid-point of its height, especially if you're working in a horizontal landscape format. Knowing both points will allow you to draw your subject squarely where you want it. The procedure is the same for both, but when you are estimating the mid-point of the length, you will be working horizontally. The subject for this demonstration is a polar bear I photographed at the zoo.

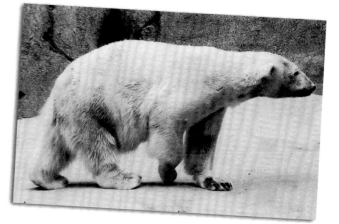

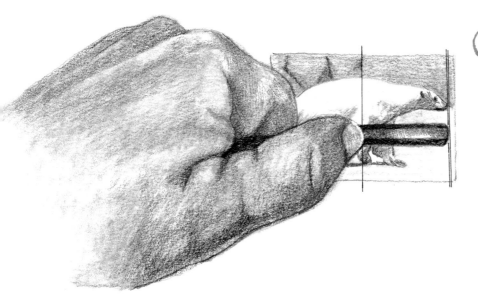

1 Estimate where you believe the mid-point is and mark it with a pencil dot. Place the end of the pencil on the farthest-reaching part of the polar bear on the right (indicated with a double pencil line), and line up your thumbnail with the mid-point.

2 Shift the end of the pencil to the mid-point without moving your thumbnail and see if your thumbnail lines up with the portion of the bear farthest to the left. If it does, you have found the mid-point.

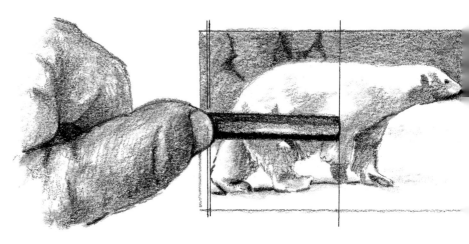

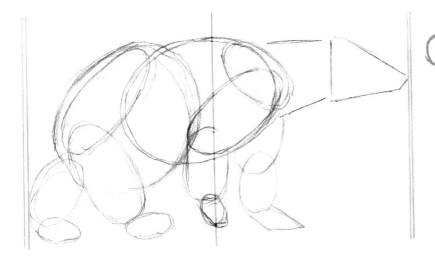

3 Decide how much room on the drawing surface you wish the subject to take up and mark both ends and the mid-point lightly in pencil. Use simple shapes to block in the bear, paying close attention to how much room each portion should take up and where it is positioned in relation to the mid-point and both ends.

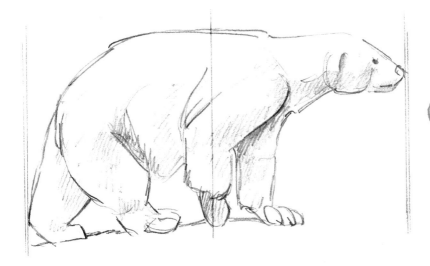

4 Refine the drawing, making corrections and adding details and shadows.

5 The finished drawing is shaded with a 5B pencil. Note how the dark background forms the outline of the polar bear's back.

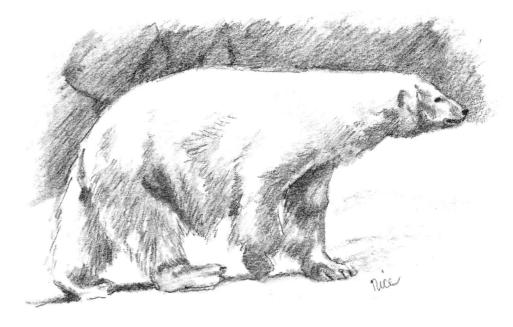

69

Making Size Comparisons

During the drawing process, it can be a problem maintaining proportional integrity between the various parts of the subject. Study the reference photo at right of the ram's skull and horns, and the two sketches below. In each drawing the skull is out of proportion to the horns. Without the photo to compare to, the sketches don't look bad, but they are far from an accurate portrayal.

In the pencil sketch, the skull is under-sized. The animal it represents would have a difficult time supporting the large set of horns. The drawing is a little less than believable and only works if the artist is trying to make an exaggerated statement.

The size of the skull compared to the size of the horns is believable in the pen and ink sketch. However, because the horns are drawn on a smaller skull-to-horn ratio than the ones in the photo, they have lost some of their magnificence. The ink sketch horns are only average.

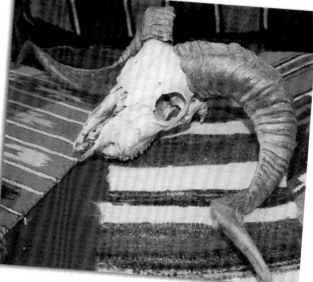

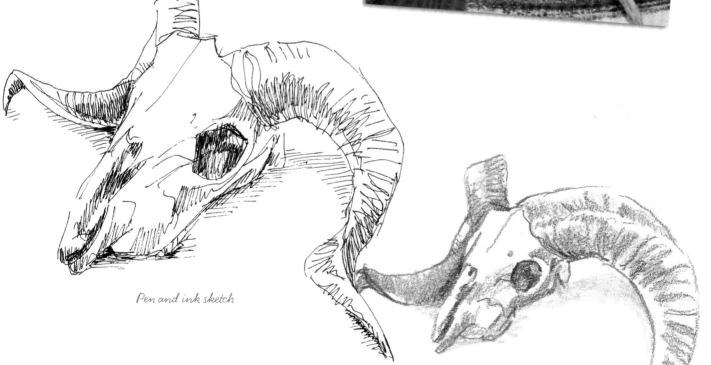

Pen and ink sketch

Pencil sketch

By making some size comparisons between the various parts of the subject, you can learn to see the subject better and gain proportional control over its components.

Start by choosing a smaller part of the subject that has a centered, blocky shape. A head is a good choice if one is working with a person or animal. For this exercise we will use the animal skull.

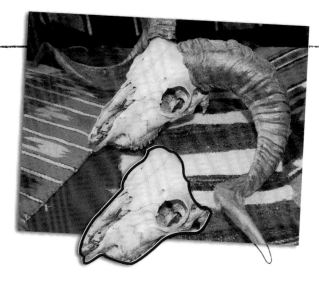

First, using the "thumbnail-on-the-pencil" method of measuring as described on pages 62-63, mark the height of the skull. Slide the pencil down with your thumbnail still marking the height, until it's even with the lower tip of the horn. As you can see, one skull fits into the space.

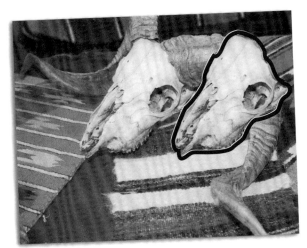

Next, use a pencil and your thumbnail to mark the width of the skull through the eye socket horizontally across. Slide the pencil to the right with your thumbnail still in place, and see how many skull-widths fit into the space between the first skull and the outer edge of the horn. As seen in the photo above, it's just under a skull's width.

Keeping these comparisons in mind, I made a preliminary pencil sketch, checked to make sure the proportions were accurate on my drawing, and finished it using a .25mm technical pen and India ink.

HEAD TO BODY **COMPARISONS**

In preparation for a drawing, I studied and made size comparisons in the photograph of the beachcomber. First I determined the mid-point of her height and width, shown as dotted lines on the photo below. That information will help me place her exactly where I want her on the drawing surface. Next I made some comparisons of her head size to her body size using the thumbnail-on-the-pencil method, shown to the left and below the photo. I discovered that her body position is approximately 4½ heads high from her back to the tip of her fingers. From the crown of her head to her posterior, she is approximately 3⅞ heads wide. The trunk is 2 heads tall and 2⅞ heads wide.

Taking the time to make these head-to-body comparisons helped me see the subject with the eye of an artist, casting aside any preconceived ideas. With this information, I am ready to start drawing her in proportion.

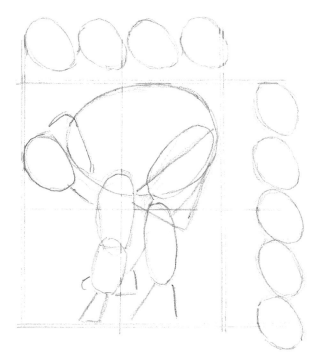

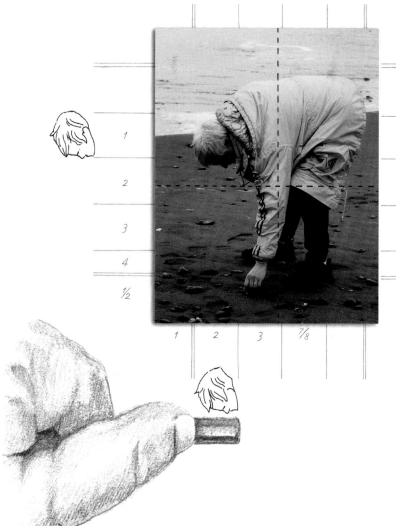

On the drawing surface I decided the space I wanted the beachcomber to take up, keeping in mind her dimensions in head-widths. I marked this area with double lines. The mid-points are indicated with single lines. These guidelines, which in actuality need only be marked very lightly, will help me block in the subject proportionally correct.

I will start with the trunk and head. Once they are drawn in the proper size and location, according to the guidelines, the rest of the body is much easier to rough in.

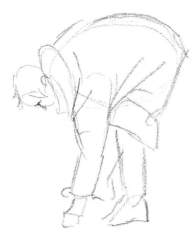

Here the drawing is starting to be refined from basic shapes into a person (left).

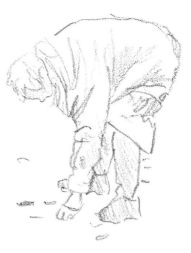

The form is established and shading has been added (right).

The finished drawing (below) is worked with a 5B pencil and shaded with a tortillion. The shade work on the beachcomber is either lighter or darker than the beach to establish a defining edge.

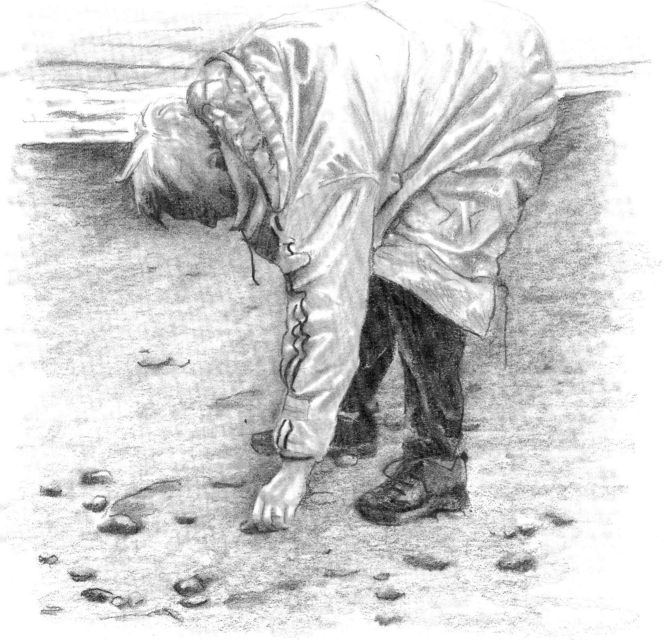

Making Quick Sketches

Quick sketches are often made from hurried observations. With practice, you can catch a pretty good likeness of a subject with just a few moments of study. However, the more time you take in making comparative observations, the better the sketch will be.

The subject for the quick sketches below is the photo of an old enamel pan sitting on a fence. The first sketch was done with minimal study of the photo. It catches the essence of the subject and is readily identified as being a cooking pan. However, the dimensions are off. The handle is too short and the pan is too short and wide. The angle of the fence rail it's sitting on is too steep.

In the second sketch, more time was taken to study the subject. Mid-points were quickly estimated and the length of the handle was compared to the width of the pan. The results were a more accurate drawing.

More comparative thinking was done in the third sketch. The height of the pan was compared to its width, and key angles and curves were studied with a calculating eye. Although it is still a quick sketch, made in just a few minutes, the third sketch is the most accurate.

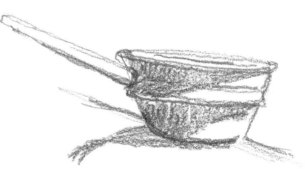

First sketch

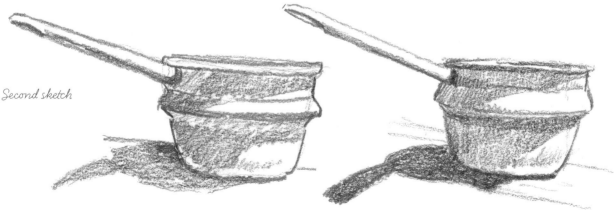

Second sketch

Third sketch

PRACTICE **EXERCISE**

Use the photos of the snow-covered apples and the old stone bridge as your subjects and make some spontaneous quick sketches. Then study the elements that make up each subject, making some size and placement comparisons. Sketch them again. Do you see any improvement?

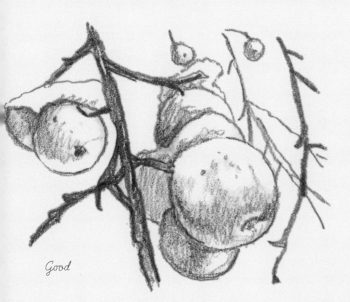

Good

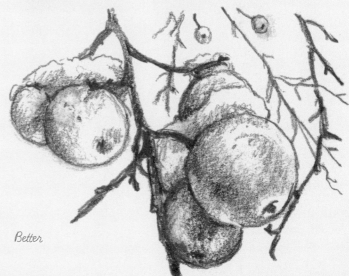

Better

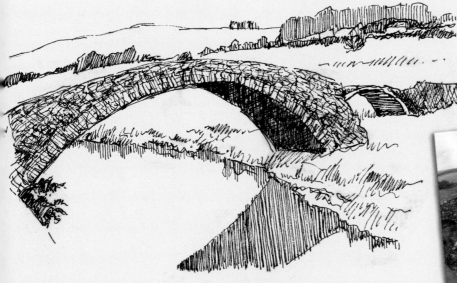

DRAWING **SYMMETRICAL** OBJECTS

Hand-sketching a symmetrical object so that the right and left side are mirror images of each other is not an easy task. One is usually more adept at drawing lines and curves on one side of the symmetrical form than on the other. The result often looks a little mismatched, like the ceramic vase shown at right. To bring an object into symmetrical balance, follow the easy steps demonstrated here.

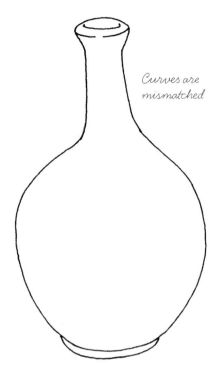

Curves are mismatched

1 *Draw a light pencil line through the center of the vase. Decide which side of the form looks the most accurate. I've chosen the left side. We'll refer to the most accurate side as the "model."*

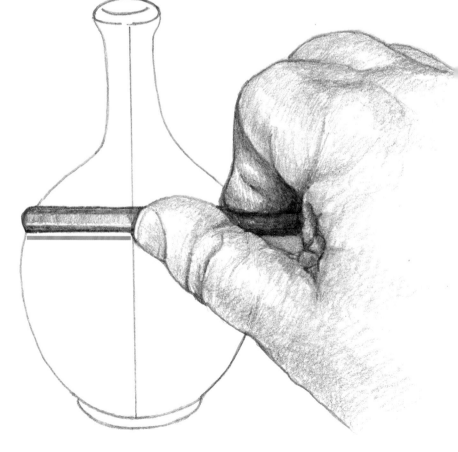

2 *Working on the model side of the object, line up the end of a pencil with a selected spot located along the outer edge. Place your thumbnail on the pencil so that it lines up with the center mark.*

3 Without moving your thumbnail from its position, slide the pencil horizontally across the paper until the end lines up with the center line. Where your thumbnail now rests should be the outer edge of the vase. However, it may actually be inside or outside the edge line. Make a light pencil tick mark where your thumbnail actually rests.

4 Repeat steps 2 and 3 just above and just below the spot you tick-marked. Add more tick marks as you go, mapping the right side of the vase to match the model side.

5 When the mapping is finished, unite the tick marks by a single line and erase the old edge. The vase should now appear symmetrical.

The subject for this exercise is a fairly symmetrical piece of Southwest Indian pottery. Begin by estimating the mid-point of the height and width of the pot. Also study its overall form.

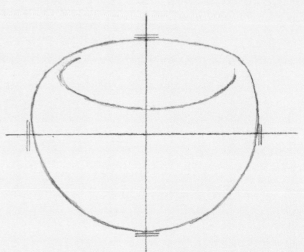

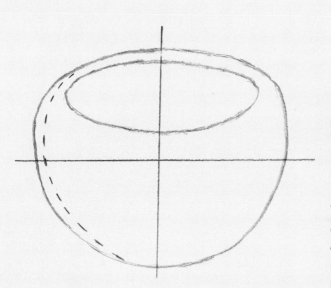

First, start with lightly drawn double pencil lines to indicate the space the pot should take up, considering that it is just a little wider at its mid-point than it is high. Rough in the shape of the pot with a pencil.

To correct the asymmetrical sides, use the right side as the model and measure across, using the thumbnail-and-pencil method of comparison demonstrated on pages 76-77. Place tick marks to indicate where the left edge should actually be in order to make it symmetrical.

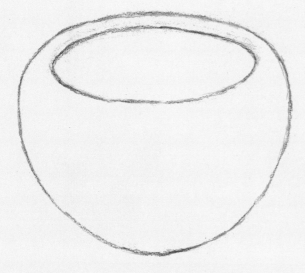

Unite the tick marks into a solid line and erase the old, incorrect edge. The pot should now look symmetrical.

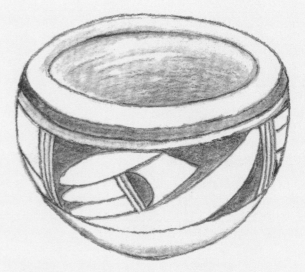

The decorative pattern on the pottery can now be added, along with the shade work on the inside.

This is the same piece of Native American pottery drawn step-by-step on the facing page. However, before the detail work was begun, a pinecone and a string of Indian trade beads were sketched in place to make a more interesting composition. Feel free to add your own embellishments to this still life and see what you can make out of it. I used 2B and 7B pencils, and a paper stub to create the shading.

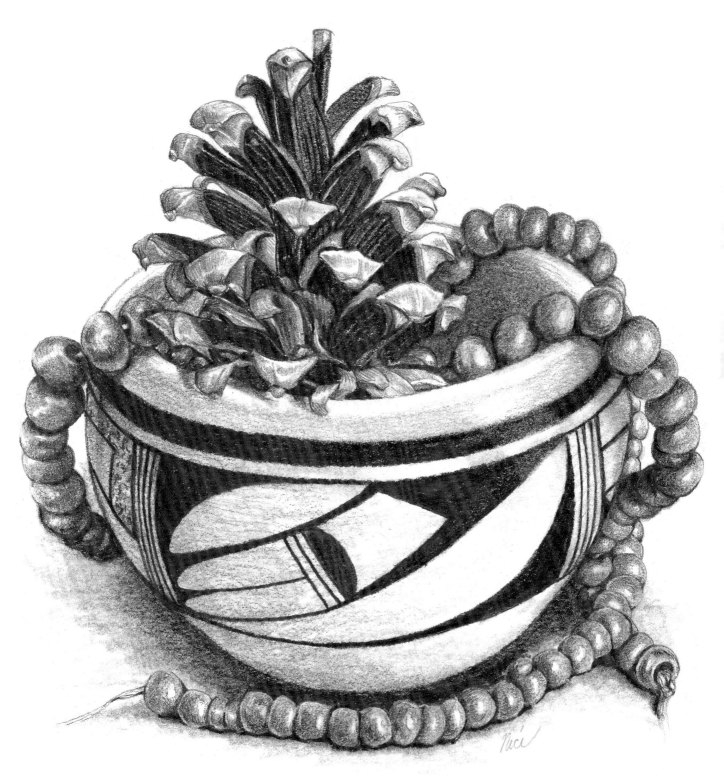

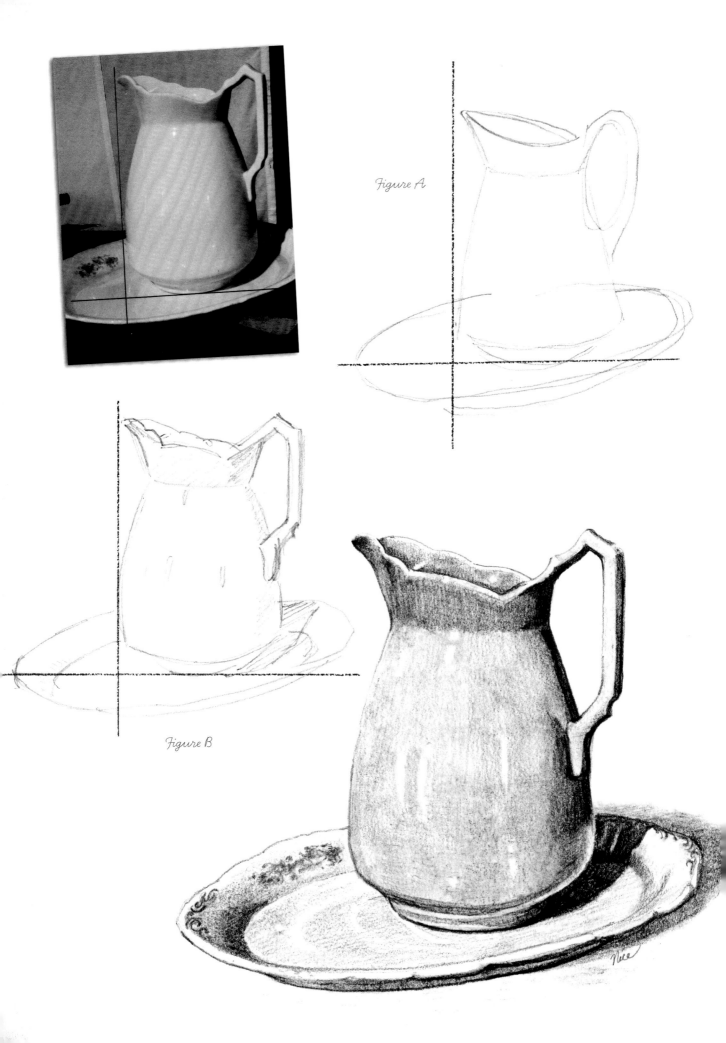

Figure A

Figure B

Finding and Fixing Drawing Mistakes

You've started a drawing. Its rough shape is penciled lightly on the paper, taking up exactly the space you allotted for it. Even though the form is still primitive, it is recognizable. The next step is to refine the drawing and correct any areas that are misshapen or out of proportion. The big question is, how do you find the areas that need fixing?

Let's consider the photograph of the pitcher and the drawings on the facing page. Figure A is the preliminary sketch of the pitcher. As its contours are reworked and refined, it also needs to be checked for accuracy. The easiest way to do this is to use a straight edge or line to help the eye make precise comparisons. You could use the edge of a ruler or pencil, or a Gridvu (see page 15). For convenience of viewing, I have drawn lines right on the photo and the sketches. Note that the vertical line drawn on the photograph lines up with the edge of the pouring spout and the widest part of the body of the pitcher. When you compare this area to my preliminary sketch and the vertical line drawn in the same location, you can easily see that the side of the pitcher is not drawn at enough of a curve. With the vertical line to use as a reference, it is not hard to correct the sketch as shown in Figure B.

You can draw as many lines or lay down as many straight edges as needed to make certain the drawing compares accurately with the subject. Comparing how things line up horizontally is just as important as making vertical comparisons. In fact, the more straight-edge comparisons you make, the better you will see both the subject and your drawing. This chapter will further explain the process that will enable you to see and draw with new accuracy. All it takes is some practice.

Sighting In the Subject

Drawing a subject with many interrelating parts and numerous angles may seem difficult, especially when you're working from life. Learning how to sight in your subject while looking past a straight-sided object like a pencil will help you see what you are drawing in a comparative manner. Comparing forms and angles to vertical and horizontal lines will reveal the information you need to know in order to draw accurately. Here's how it works.

Hold the pencil up in front of the subject you are wishing to draw, either in a vertical or horizontal position. See what lines up along its edge. Note any curves or angles that veer away from the edge of the pencil. How steep are they? Record what you see on your paper in the form of light, quick sketches. When you have learned what you can from one position, shift the pencil to another location and make more comparisons. This process is ongoing. As you draw, you will need new information. Get in the habit of lifting the pencil, sighting in the subject and getting accurate information.

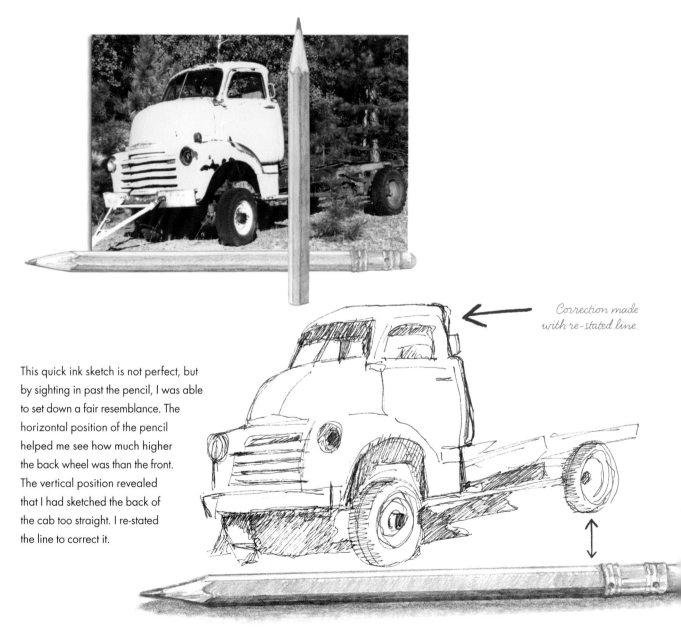

Correction made with re-stated line.

This quick ink sketch is not perfect, but by sighting in past the pencil, I was able to set down a fair resemblance. The horizontal position of the pencil helped me see how much higher the back wheel was than the front. The vertical position revealed that I had sketched the back of the cab too straight. I re-stated the line to correct it.

Lay a pencil vertically and horizontally across the photo of the truck below as if you were sighting in the subject in the field. See what you can discover about its form. Make some sketches if you like and study the observations I came up with. Do they look accurate to your eye?

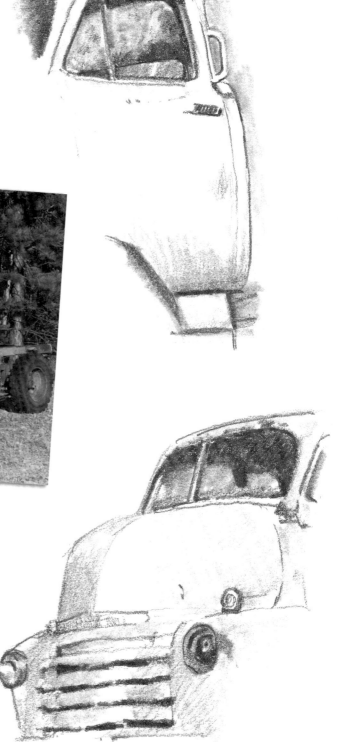

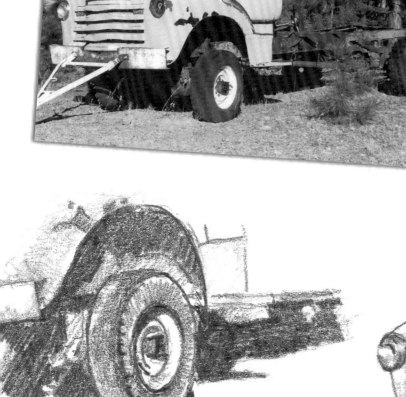

WORKING WITH A **LINE GRID**

A pre-drawn grid of vertical and horizontal lines can be very useful when working on flat surfaces. It can be laid over photographs to help you make comparisons in several areas at one time. It also can be laid right over your drawing surface for quick checks in both directions. The nice thing about a grid is that the lines are thin to allow you to see more of the subject, and the grid can be shifted to line up with any points you desire.

The Gridvu (see page 15) is a grid system printed on a clear acrylic plate with a level and bubble to make sure it is horizontal to your subject. It also has markings to help you compare angles and find the center point of your subject. I've found it to be accurate and handy, especially for work in the field.

You can create your own grid system by drawing black ink lines on a thin sheet of plastic, and then sealing the lined sheet with a protective cover of sticky-backed laminate. This prevents the ink lines from rubbing off. Narrow grids such as the ½-inch (1.27cm) one shown here are useful for working with small drawings or photographs, like the snapshot of the abandoned house at right.

Two grids of different sizes can be used to increase or decrease the size of the drawing compared to the subject. You work along square by square, making comparisons and creating the drawing section by section. Although this results in accuracy, I personally find it too confining and time consuming. I like a little leeway to make mistakes and learn from them.

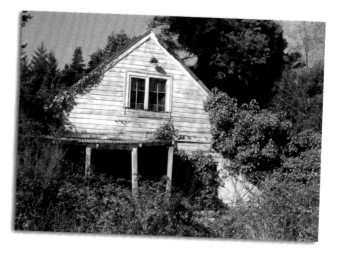

1/2-inch (1.27cm) grid

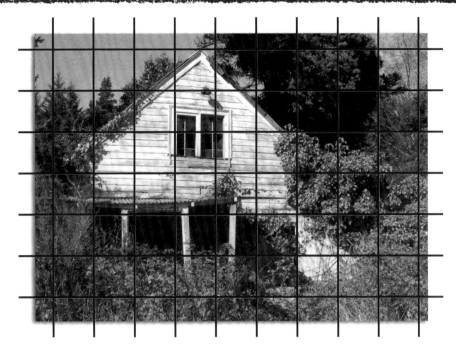

The grid laid on top of the photo of the derelict house reveals the crookedness of the porch support posts. It was fun to make a statement by slanting the posts even further in the pen and ink drawing below.

Scribble lines were used to suggest the overgrown, tangled foliage. The sketch was done with a Rapidograph technical pen in nib sizes .25mm and .50mm.

AVOIDING DRAWING **ERRORS**

The best way to avoid drawing errors is to begin your work by getting to know the subject as well as possible. Look at the photo of the mule deer with more than a superficial glance. Study it and see what you can learn. Did you notice that:

1 The top line of the deer's back is fairly horizontal.

2 The left hind leg is the longest.

3 The right foreleg is the shortest and is off the ground.

4 The ears and the face are the same length.

5 The hooves and the lower legs are the same width.

I started the drawing by estimating the mid-point of the width and height of the deer in the photo. Then I marked it on the drawing surface and blocked in the basic shapes, as seen below in Figure 1.

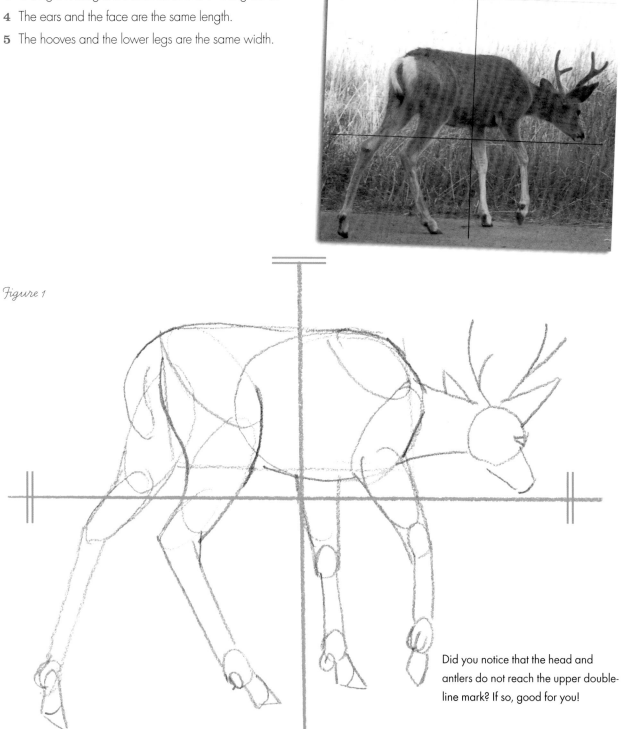

Figure 1

Did you notice that the head and antlers do not reach the upper double-line mark? If so, good for you!

Figure 2 shows the preliminary deer sketch streamlined into a more refined form with the lightly drawn building-block shapes erased away. Now is the time to mindfully compare the drawing to the subject to locate any areas that are out of alignment or mis-sized.

To help me make more accurate comparisons, I have drawn vertical lines past the rump, hip and shoulder of the deer in both the photo below and in Figure 3. These points were selected because they are easier to pinpoint in the drawing than, say, mid-chest.

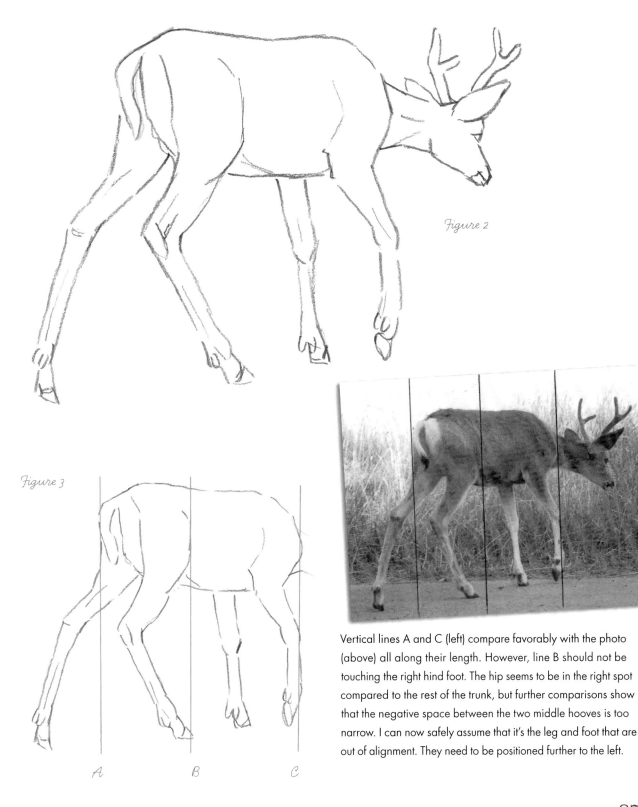

Figure 2

Figure 3

A B C

Vertical lines A and C (left) compare favorably with the photo (above) all along their length. However, line B should not be touching the right hind foot. The hip seems to be in the right spot compared to the rest of the trunk, but further comparisons show that the negative space between the two middle hooves is too narrow. I can now safely assume that it's the leg and foot that are out of alignment. They need to be positioned further to the left.

The use of horizontal comparison lines reveal another problem area in Figure 4. Line D shows us that the antlers are too short, yet they seem in proportion to the size of the head. The conclusion is that both the head and antlers were sketched too small. Line E should run past the crown of the head. Instead, it passes just below it. The neck is positioned slightly too high.

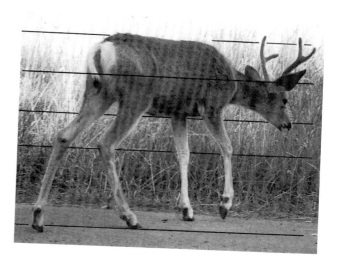

In Figure 5, the head and antlers have been enlarged slightly and the angle of the neck has been lowered. The right hind foot has been moved toward the back of the deer. With these corrections made, all the points now fall into perfect alignment. Whether or not areas of misalignment are off enough to need fixing is up to you. However, with straight-edge comparisons and patience, you will be able to find the problem areas.

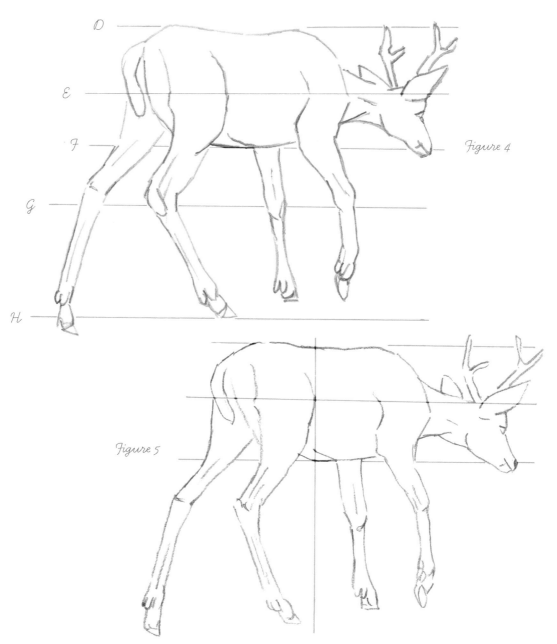

Figure 4

Figure 5

Once the corrections are completed, the details can be added and the shade work begun as in Figure 6.

Figure 7 shows the completed pencil drawing. Note that the strokes were made in the direction in which the hair lays and are left a little rough to represent the texture of the coat.

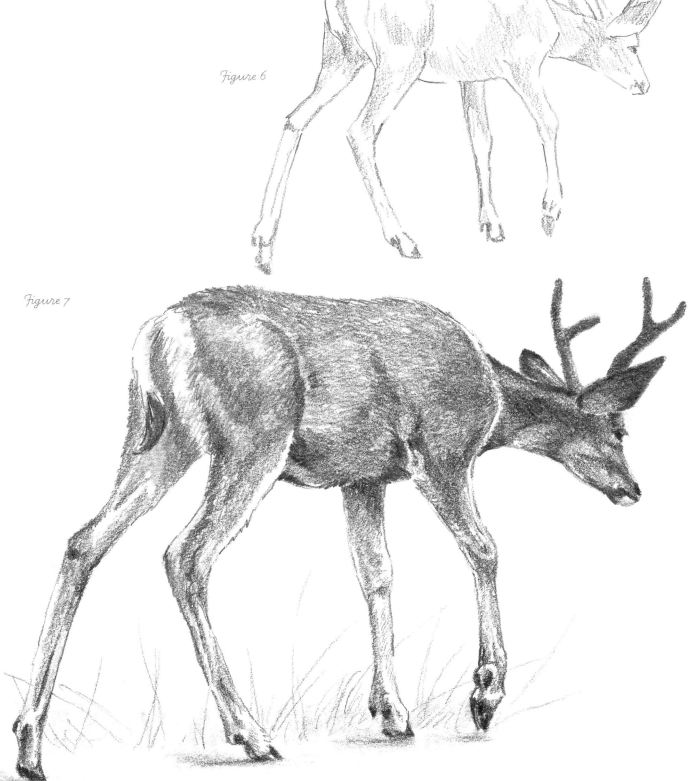

Figure 6

Figure 7

Verifying Angles

Some subjects, especially buildings with gables, present the artist with angles that need to be duplicated with a fair amount of accuracy. Otherwise the roof of the house may appear rather awkward looking. Here is a quick way to check the angles while you're working on location.

Pick up a pencil in your drawing hand and hold your drawing surface in the opposite hand. Next, hold the pencil up in front of your subject and sight along the angle in question as shown in Figure A. Keeping an eye on the pencil and the gable so they stay aligned, bring your drawing up behind the pencil so it takes the place of the subject in your view, Figure B. If you haven't shifted the angle of the pencil, you will quickly see if the gable you have drawn is a good match. It will also be obvious if the angle is too steep or too shallow. With practice, your eye will begin to see and judge angles with a greater amount of precision.

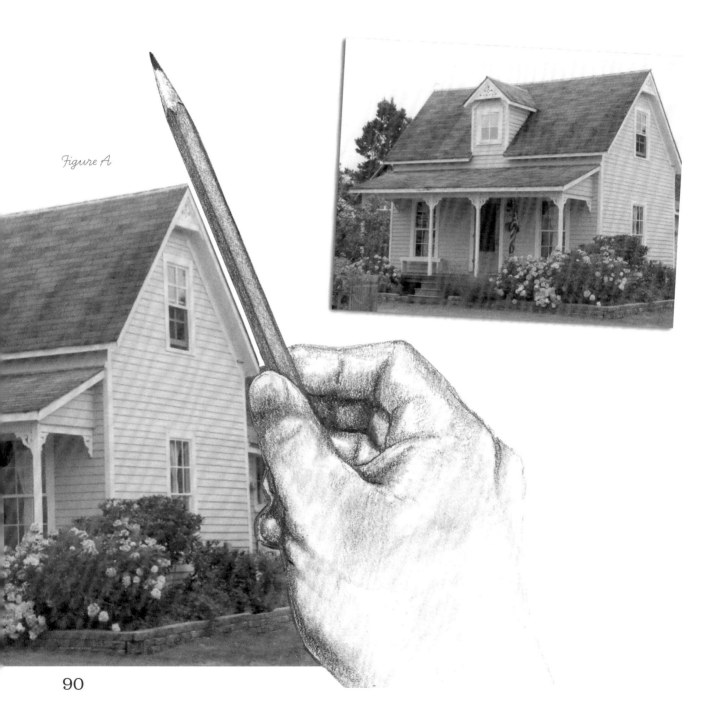

Figure A

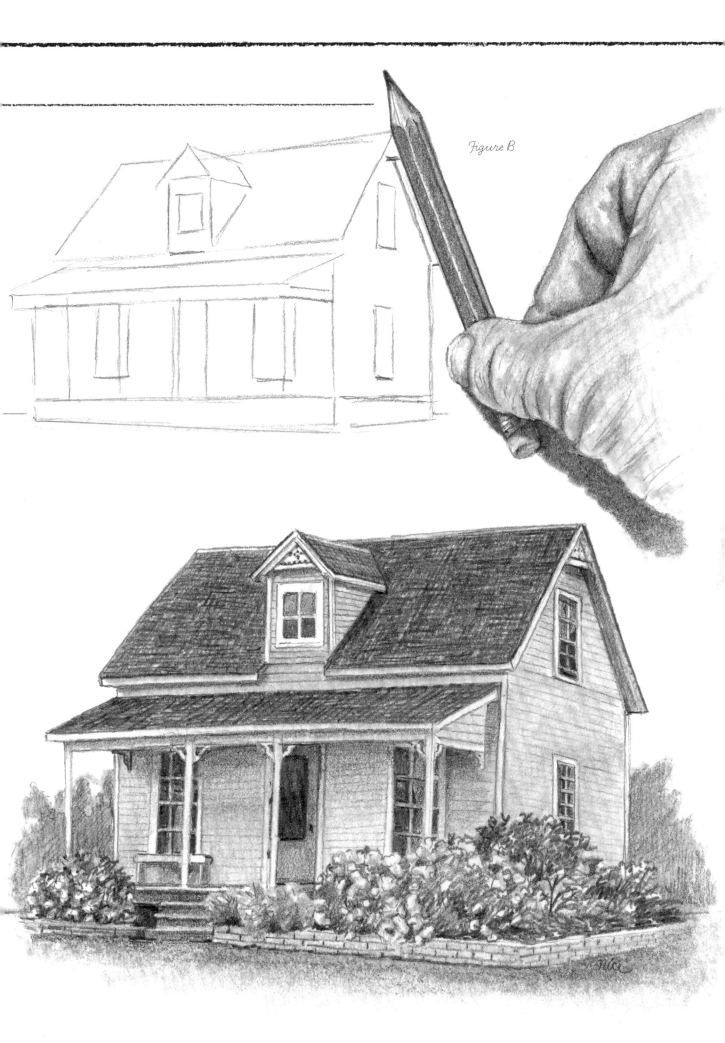

Figure B

PRACTICE **EXERCISE**

Study the photograph of the boats and the sketches of them below. Figure A shows them roughed in, while Figure B is the same sketch with shadows added to give them a little clearer form. There are two inconsistencies between the subject photo and the sketches. One has to do with an angle at the wrong slant and the other is an alignment problem. If you can spot them right off, then your artist's eye is already well developed.

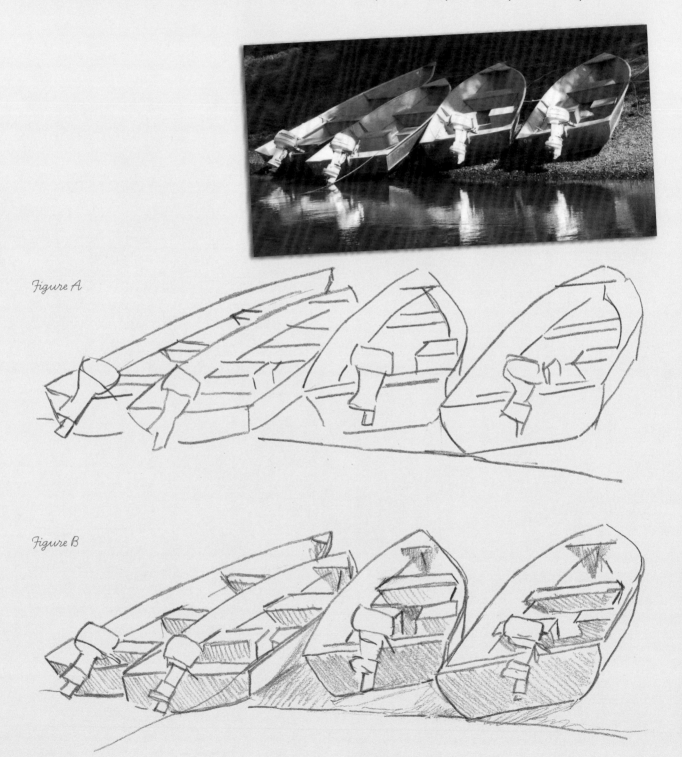

Figure A

Figure B

To help your eye spot the angle that is off, align a pencil beside an angle in the photo and slide it down to match up with the same angle in the sketch as shown in Figures C and D. The trick is to keep the angle the same while you are moving the pencil! Place the sketch right below the photo and arrange it so that each transition will be smooth and easy. As you can see, there is not an inconsistency between the angles shown in the example. The problem is further down the row. If you have not spotted it yet, grab a pencil and compare some more angles.

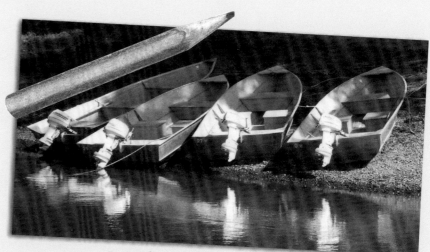

Figure C

Figure D

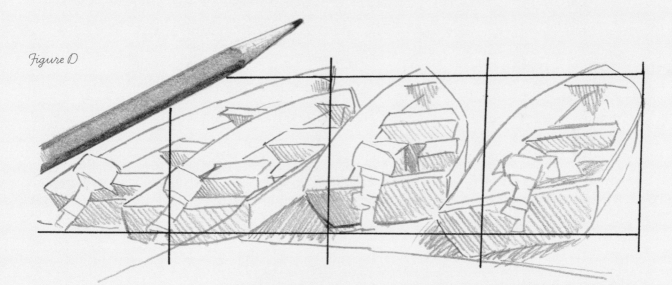

The alignment problem can be located by comparing the boat parts that touch the grid lines placed over the drawing above with their counterparts in the grid-lined photo at right. When you find the spot where they don't match up, you have located the drawing error.

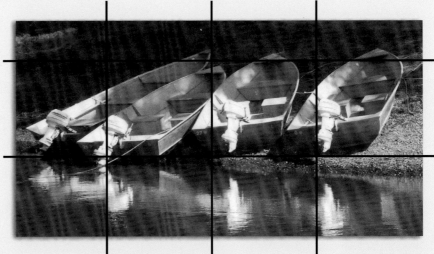

93

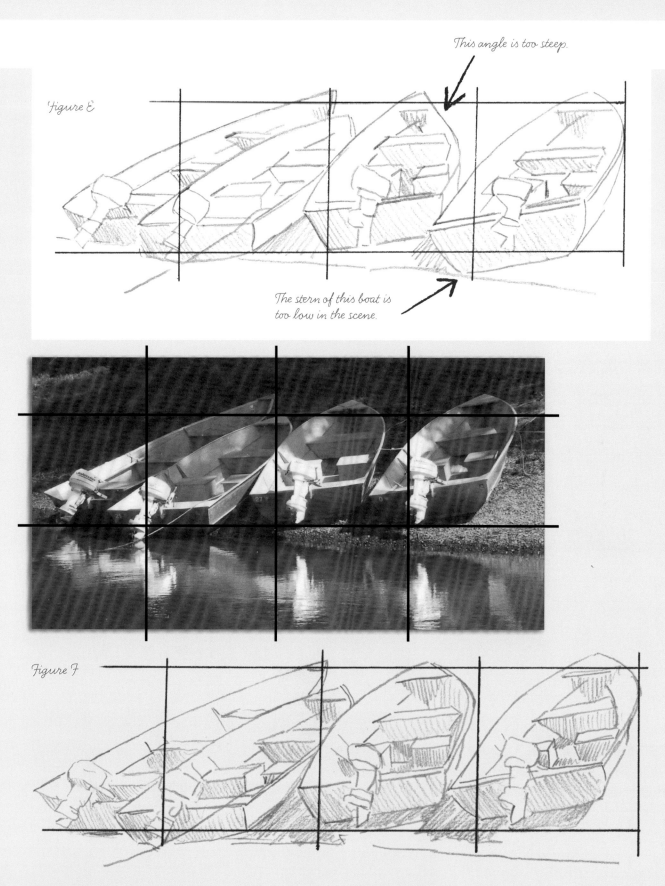

Figure E

This angle is too steep.

The stern of this boat is too low in the scene.

Figure F

The corrections have been made in this sketch and everything lines up to match the photo.

Re-stated line.

This is an ink sketch of a boat made in the field, using a technical pen with .25mm and .35mm nibs. When working loose and sketchy in ink, you can make corrections using re-stated lines without harming the overall look of the drawing. The lines of this sketch were re-stated several times as errors were found and corrected.

The finished drawing of the fishing boats is shaded using 4B and 5B pencils and a blending stub. Scattered horizontal lines denote the reflective surface of the water.

Simplifying the Scene

One of the great pitfalls of creating a drawing is feeling compelled to include everything you see in the scene. Unlike a camera, the artist is not bound to record everything laid out before him. Just because you *can* draw it does not mean you *must* draw it. In fact, subjects and scenes often benefit from some thoughtful pruning to make them easier to draw and to improve their composition. Here is a list of simplification ideas.

1 Choose a main subject for your drawing and zero in on it.

2 Remove anything that competes with the main subject in an overwhelming manner. There should be only one center of interest in your drawing. Example: Two cute puppies at opposite corners of the drawing surface. Group them together or remove one.

3 Eliminate objects that are in opposition to the theme, mood or timeframe of the drawing. Example: A modern car parked in front of a Victorian house.

4 Avoid strong lines that exit out of the scene, like straight, uninterrupted tree trunks. They will pull the viewer's eye right out of your drawing. Soften them, shorten them, block them with other lines or remove them if they serve no purpose.

5 Trim the clutter. Too many little, secondary objects scattered about can be distracting.

6 Use your artistic license. If you just don't like it in the scene, take it out.

Telephone pole does not add to the pastoral scene. Take it out.

This strong line exits the frame; raise the sky above it.

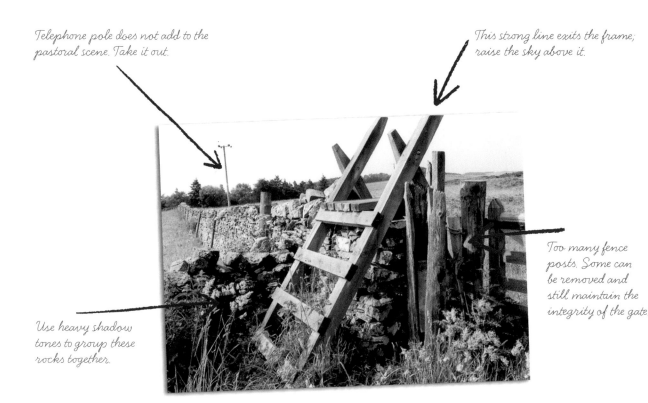

Too many fence posts. Some can be removed and still maintain the integrity of the gate.

Use heavy shadow tones to group these rocks together.

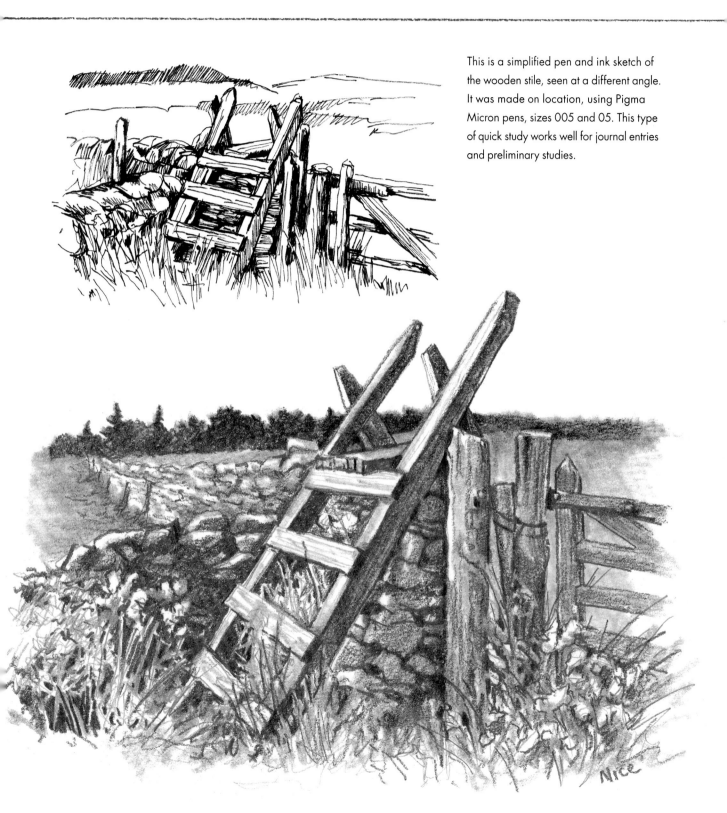

This is a simplified pen and ink sketch of the wooden stile, seen at a different angle. It was made on location, using Pigma Micron pens, sizes 005 and 05. This type of quick study works well for journal entries and preliminary studies.

This finished pencil drawing represents the scene in the photo at left, minus the telephone pole and some of the wooden fence posts. Simplification gave the landscape a cleaner appearance and improved the overall composition of the drawing.

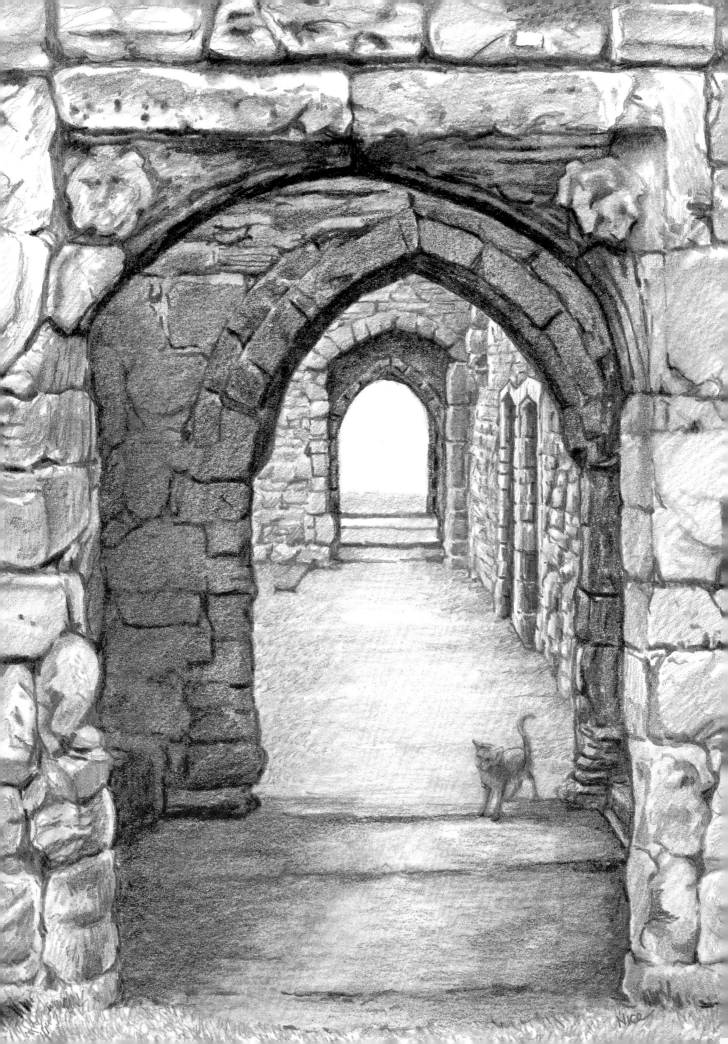

6 Understanding the Illusion of Perspective

Perspective is the technique of depicting dimensional objects on a flat surface. In other words, it's the illusion of depth where none actually exists. Cameras perform this illusion as they capture the three-dimensional images of beings, places and things and display them on photo paper or a flat screen. By following a few basic principles, you can master the techniques of perspective and, with practice, create an even better illusion than the camera can, which often takes the principles of perspective to an unbelievable extreme. Here are the five basic principles of perspective you should become familiar with:

1 As objects recede into the distance, they will diminish in height, width and clarity until they disappear altogether.

2 The artist's point of view (eye level) and the horizon line are one and the same.

3 There is only one eye level in a composition and all elements within that drawing must relate to it.

4 All lines that are parallel to the ground plane and each other in actual life will seem to grow closer together as they recede into the distance, until they come together along the horizon line at a point called the vanishing point.

5 Sets of parallel lines that do not correspond to a horizontal ground plane, like the front and back angled edges of a slanted roof, have an oblique vanishing point.

Consider the pencil drawing at left of an old English castle in the village of Ashby de La Zouch. You should be able to tell by looking at it where my eye level was when I sketched it. Was I lying in the grass, standing or looking down from a high tower? The eye level (horizon) is mid-scene, so I was standing. The arched doorways are all the same size in reality, yet note how they get smaller and less detailed as they recede into the distance. The cat provides a bit of live interest to the drawing, as well as a sense of size. The light and shadowplay suggests that the roof has collapsed and the sun is streaming into the interior room. As you can see, the creative development of form, depth and distance can turn a drawing into a virtual experience and is well worth incorporating into your artistic bag of tricks.

Ruins of an old castle in Ashby de La Zouch, England (opposite)
Pencil drawing using 2B and 6B pencils on 8 ×10-inch (20 × 25cm) drawing paper.

Creating Depth and Distance

OVERLAPPING SHAPES

One of the easiest ways to create the illusion of depth in your drawing is to overlap some of the forms. Consider the bucket and the metal cover sketched at right. The two subjects in the scene seem to be of equal importance and both are clamoring for the viewer's attention. The bucket is sitting on a round piece of wood. It appears to be lined up evenly with the metal cover, or perhaps it is just a little bit further back. It's hard to tell for sure because there is little indication of depth in the drawing.

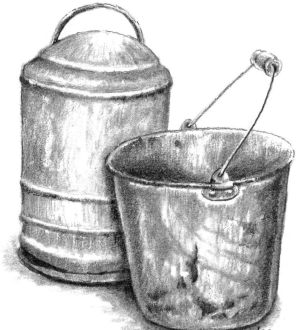

By simply moving the bucket in front of the metal cover, as shown in this pencil drawing, the two problems found in the sketch above are solved. First, the individual objects are now grouped into one focal point. Second, there is a definite feeling of depth in the drawing.

The edges of overlapping objects can be kept distinct by using contrast of value and texture to set them apart, as shown in this ink drawing of wooden decoys.

AERIAL **PERSPECTIVE**

The clarity of objects diminishes as they recede into the distance. This is due to the atmosphere. Although the air may seem transparent on a clear day, it is still peppered with dust, moisture and pollen, not to mention pollution particles. This near invisible screen puts a veil between the viewer's eye and what is being looked at. The more distant the object, the more it is obscured. The atmospheric haze mutes details and values. It also filters out light rays, especially the reds, oranges and yellows, so that distant hills take on a blue-green, blue or purplish hue.

Decreasing the details, muting the colors, and softening the values of distant objects to create the look of depth in a drawing is called *aerial perspective*. When working in pencil, you can use harder leads (2B and HB) to give a faded appearance to background areas. In pen and ink drawings, using simpler lines such as parallel or contour lines, spreading lines further apart and creating softer edges will make objects look faded or distant. Decrease detail work as objects recede, as shown at bottom in the drawing of the three washtub planters.

The Horizon Line

By definition, the horizon is an imaginary horizontal line that marks where the earth plane meets the sky. Providing there are no intervening objects in the way, you can see a hazy version of the horizon line when standing before an endless stretch of flat land or calm water.

Eye level is a flat imaginary plane that stretches horizontally from your eyes to the scene you are viewing. Eye level and the horizon line occur in the same place in the scene. If you are standing on a bluff, looking straight out to sea through the viewfinder of a camera, your eye level and the horizon will be high in the frame. You will see a small area of sky and lots of water. If you stand on the beach and look directly out to sea, the horizon (eye level) will appear somewhere near the middle of the frame, depending on how tall you are. If you lay down in the sand and take a worm's eye view of the sea, your eye level will be very low and so will the horizon. You will see mostly sky. Turning or tipping your head to get a better view of objects within a scene will not noticeably affect your eye level or the perspective of your drawing. However, changing your height or location will.

Two important points to remember:

1 The horizon and eye level are located along the same horizontal line. When referring to perspective, they can be spoken of interchangeably.

2 The horizon line (eye level) will vary depending on the height and location from which the subject or scene is viewed.

High eye level = high horizon line

Low eye level = low horizon line

MAINTAINING PROPER **PERSPECTIVE**

There is only one horizon line (eye level) in a composition and all the elements within that composition should relate to it to maintain proper perspective.

Consider the boxes in Figure A below. Pretend that they are resting on invisible glass shelves. Eye level is located behind the boxes on the middle shelf because the viewer is looking directly at them. The box on the bottom shelf is below eye level and the viewer is looking down upon it. He sees the top of the box. The box on the upper shelf is just the opposite. The viewer is looking up when viewing it and sees the bottom of the box. All of these boxes relate to the same horizon line, as proved by extending their sides (dotted lines) until they cross. They all cross somewhere along the same horizon line.

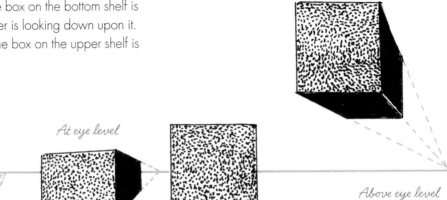

Figure A

Horizon line (eye level)

At eye level

Above eye level

Below eye level

In Figure B below, I have taken the box from the upper shelf and moved it to the lower shelf without changing its perspective. We should be looking down and seeing the top of the box; instead we are seeing its underside as if it were tipped up and balancing on its back edge. Quite impossible! Making the box into a house as shown in Figure C presents a weird, surreal image. Neither the box nor the house relates to the designated horizon line in their present position and are out of perspective.

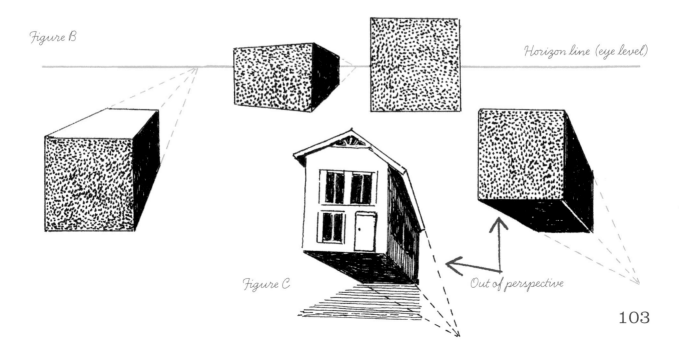

Figure B

Horizon line (eye level)

Figure C

Out of perspective

103

DIMINISHING **SIZES**

Objects appear smaller both in height and width as they recede into the background. The distance between evenly spaced objects also seems to diminish.

Consider the photograph of the pier and the people walking along by the railing. The people on the left side of the photo are closer to the foreground and appear much larger than the people on the right, who are further away. This can be clearly seen by comparing the people on the far right to the figures in the circular cut-out.

Note that the railing posts and piling posts become shorter, narrower and more closely spaced as they recede into the distance. Observe that if lines are extended from the top and bottom of the railing and from the bottom of the pilings, they meet at one point located at the eye level of the photographer.

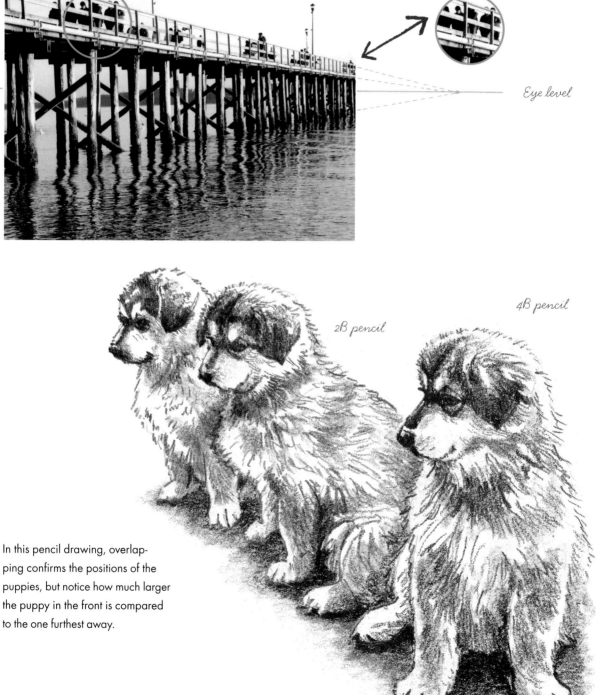

Eye level

2B pencil

4B pencil

In this pencil drawing, overlapping confirms the positions of the puppies, but notice how much larger the puppy in the front is compared to the one furthest away.

104

To determine how large to draw various figures scattered throughout a scene, you will first need to determine where your eye level is as you gaze at the figures. Are you looking directly at their eyes, their shoulders, their waists, etc?

Choose one of the figures and sketch it in, maintaining its proper body proportions (how many heads tall it should be) and its correct size compared to nearby objects such as doorways, fences, trees, etc. Remember where your eye level was as you looked directly at the figures? Pencil the eye level (horizon line) lightly across your drawing surface so that it passes through the figure you just drew at the proper height.

The example shown below is a drawing of my art students as they sketched an outdoor scene. My eye level lined up in the approximate area of each figure's ear lobe, depending somewhat on their height and head position. The first figure I drew was Figure A. Past her ear lobe, I drew

in the horizon, shown as a solid line in the example. Figure A is my control model. Her height will determine the correct sizes for the other people in their various positions.

The process is fairly simply. A dot is placed on the horizon line, on the left and right side of control Figure A. Broken lines are extended from each horizon dot past the crown of Figure A's head and each of her heels. To maintain a proportionate scale of sizes throughout the scene, each figure is drawn so that it fits within the confines of the dotted lines, as shown in Figures B and C. Shorter figures may not quite touch the top line. If you wish your figure to be somewhere other than between the guidelines, determine how tall it should be for a given distance in the scene and shift it to the left or right to draw it. Note that Figure B was shifted to the left and redrawn, maintaining the correct height for her placement in the scene.

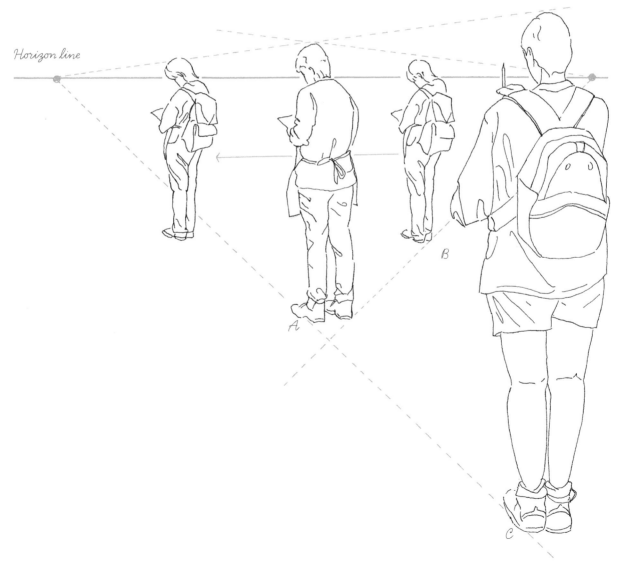

Horizon line

A

B

C

Understanding Perspective

LINEAR PERSPECTIVE

When lines run parallel to the ground plane and each other, a visual phenomenon occurs that makes the lines seem to move closer together as they recede into the distance. This is known as *linear perspective*. If these sets of parallel lines extend far enough, they will actually meet at the same point along the horizon line known as the vanishing point. The photograph of the pier on page 104 is a good example of this.

While there can be only one horizon line per composition, there may be numerous vanishing points located along that horizon line to accommodate sets of parallel lines running in different directions.

Vanishing points

Horizon line

The dotted lines represent sets of parallel lines extended to their vanishing points on the horizon. Note that you can't see the true foundation of the outhouse because it's hidden behind the hill.

FINDING THE **EYE LEVEL** IN PHOTOS

When working from reference photographs it can often be a challenge to determine where the photographer's eye level was as the picture was taken. You may have a little leeway when drawing landscape scenes as the horizon is often hidden behind shrubs or hills and pinpointing its exact location is not crucial. But when you begin to add buildings and structures, knowing where eye level is located becomes very important.

If the photo contains sets of parallel lines merging toward each other like the railings on the foot bridge seen below, extend two or more of them and see where they cross. The crossing spot is the vanishing point, which of course rests on the horizon line.

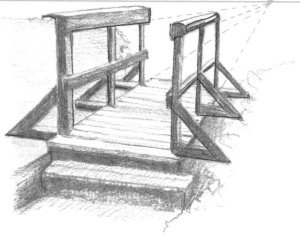

Horizon line *Vanishing point*

Sets of parallel lines may not reach their vanishing point within the confines of the drawing surface. They may converge slowly, moving across onto a second sheet of paper or way beyond. This is especially true when the structure is turned only slightly, like the picnic pavilion in the photo at right. Keeping in mind that parallel lines above the horizon converge downward and those below converge upward, it stands to reason that those on or near the horizon will be horizontal. Rather than plot the lines of the pavilion to the end of its extended course, simply extend some of the parallel lines from the shingles and see which row runs horizontally. Line B is the closest to horizontal and marks the approximate horizon.

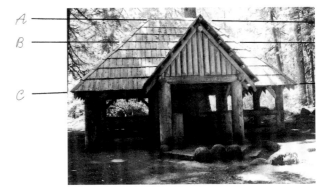

A

B

C

ONE POINT PERSPECTIVE

When a square or rectangular subject, sitting level, is viewed straight on, one vanishing point is all that is needed. The viewer may either be centered in front of the subject, on top of it (road, railway track, dock, floor, etc.) or inside of it (room or passageway). If there is more than one object in the scene, they must all be lined up squarely facing the viewer in order for one point perspective to be used.

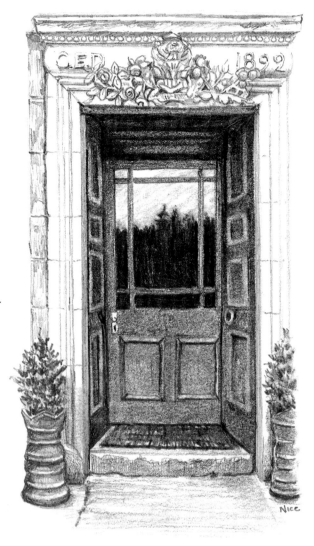

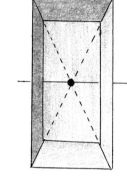

Diagram of the doorway

The pencil drawing of the recessed doorway is almost perfect one point perspective. However, the outer door on the right has swung outward just enough so that it requires its own set of vanishing points. If it had been pushed flush against the wall, one point perspective would have worked all the way around, as shown in the diagram above.

The diagrams below show boxes in one point perspective. Sometimes it helps to map out the hidden edges of a subject in order to better understand its volume and how all of its sides fit together perspective-wise. This is called "drawing through."

Top view: one point perspective

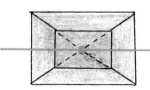

Below the horizon line

Above the horizon line

Person

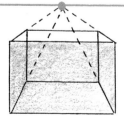

In front of the horizon line

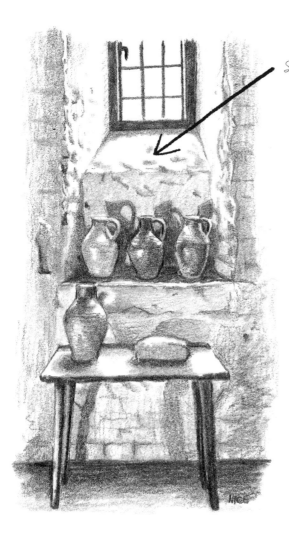

Sloping ledge

Horizon line

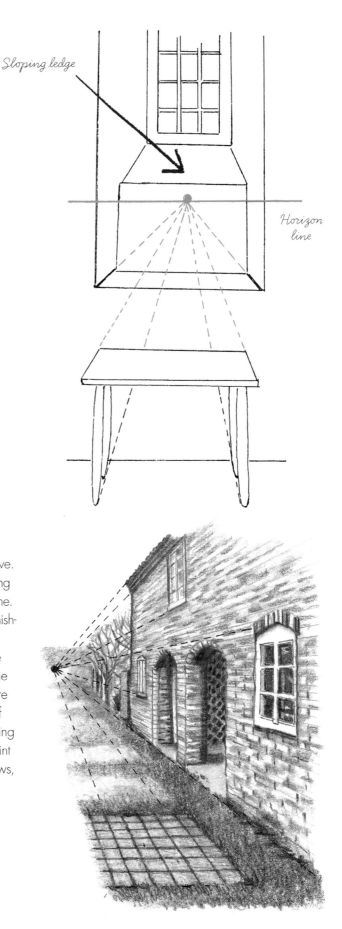

Here are two more examples of one point perspective. In the drawing of the room above, you'll see that the sloping ledge below the window is not parallel to the ground plane. Therefore, it does not relate to the horizon line and the vanishing point like the flat ledge and the table both do.

In the drawing at right, the viewer is standing beside the building, looking straight down its length. This same type of view is often encountered in street scenes, where the road is located in the middle ground and a row of receding buildings is located on either side of it. Providing that the structures are squarely facing the street, one point perspective can be used to plot the walls, doors, windows, etc., on all the buildings.

TWO POINT PERSPECTIVE

When a square or rectangular structure is viewed toward one end or at the corner, you'll see two sides of the structure. Each side will have its own vanishing point, since the two sets of parallel lines will be merging toward the horizon line on opposite sides of the structure.

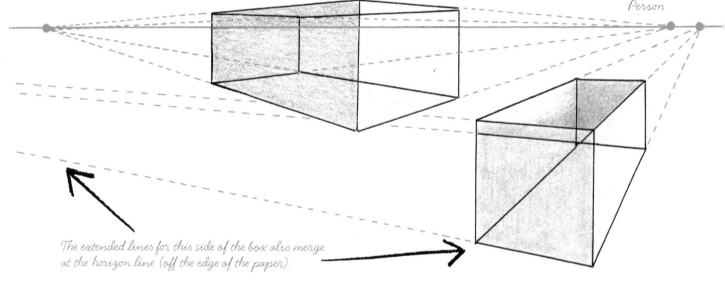

Top view: two point perspective

Person

The extended lines for this side of the box also merge at the horizon line (off the edge of the paper).

In the diagram above, note that each vanishing point relates to two sides of the box—the sides across from each other. Although the multitude of lines seem to run as random as cobwebs, if you follow each one from its vanishing point to the box, you will discover that each dotted line becomes either the bottom or top edge of the rectangle.

This little ink drawing of a curio shop started out as a rectangular shape, with two point perspective.

110

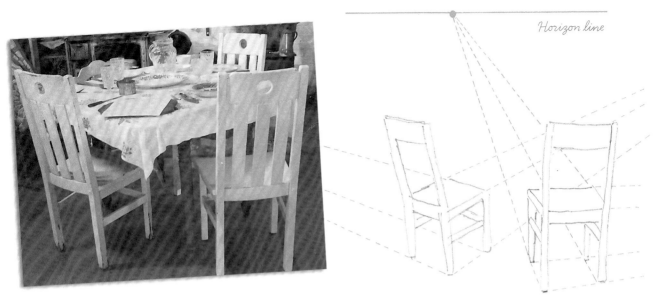

The seats and legs of these chairs form rectangles that have two point perspective.
Eventually all of the sets of extended lines will merge along the same horizon line.

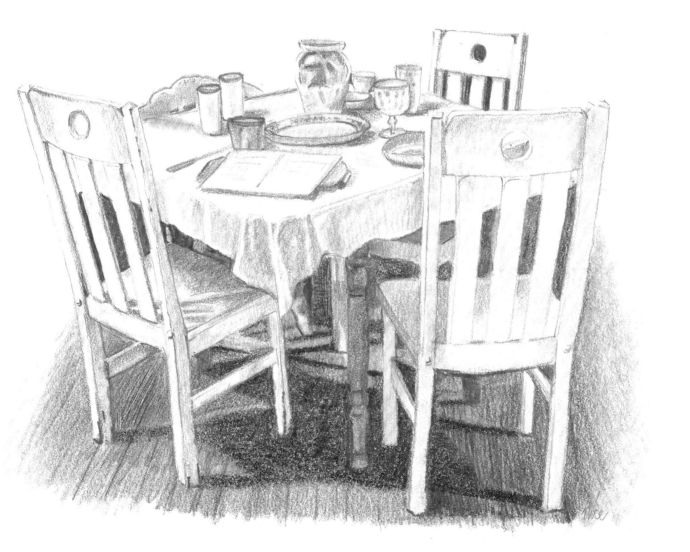

PRACTICE **EXERCISE**

Although the preferred way of sketching Is to study the subject and draw it freehand, creating a house using linear perspective is good practice. It helps set the process in your mind so it can be recalled when a perspective problem occurs in your freehand drawings.

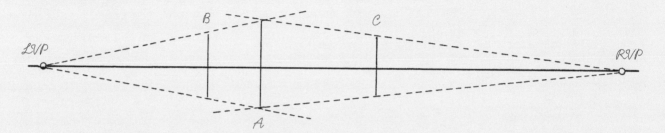

1 Draw a horizon line horizontally across the page and mark a left vanishing point (LVP) and a right vanishing point (RVP) on the far edges. Decide how tall you want the building to be and draw a vertical line (A) across the horizon line, setting it off center to the left just a little. Keep the line around 1-inch (2.5cm) high for this exercise.

2 Draw dotted lines running from the top and bottom of vertical line A to the left and right vanishing points. These lines form the top and bottom wall of the house. Decide how long and wide your house will be and add vertical lines B and C.

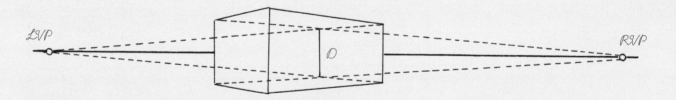

3 Now we will need to find the hidden walls of the house. Draw dotted lines running from the LVP and the RVP to the far corners of the building. Where they cross is the hidden corner (line D).

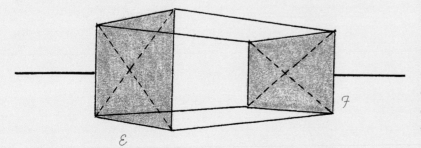

4 The center of a wall, seen in perspective, can be determined by drawing diagonal lines from the upper corner to the opposite lower corner to form an X. Where the legs of the X cross is the center. Find the center of walls E and F as shown. Note that the wall closest to the viewer (E) is always larger.

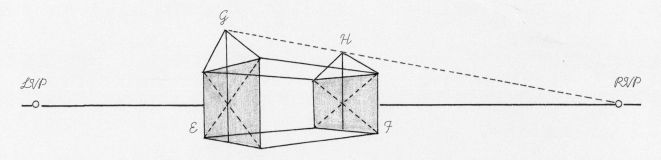

5 The next step is to build the framework for the roof. Begin by drawing a vertical ridge pole (G) through the perspective center of wall E. Always draw the ridge pole on the end closest to you first. Make the ridge pole as tall as you like, keeping in mind that the taller it is, the steeper the roof will be. Run an extended dotted line from the right vanishing point (the side opposite the ridge pole) to the top of ridge pole G.

6 Run a ridge pole (H) up through the center of wall F until it touches the extended line. The length of the ridge of the roof will be the space between G and H.

Draw in the gables by running diagonal lines between the tops of the ridge poles and the upper corners of walls E and F.

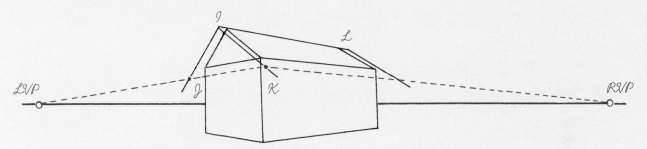

7 Now that the framework has been drawn, the guidelines for the back side of the house can be erased.

To start the roof cap, extend the roof ridge over the gable just a little as shown in (I). Draw a diagonal line running parallel to the side of the gable from (I) well past the corner of the building. Decide how low you want the eave to hang and mark it with a dot (J).

Draw a line (K) running parallel to the other side of the gable, stretching from (I) well past the corner of the building. Run an extended dotted line from the left vanishing point, through point (J) and across line K. Where the dotted line crosses line K marks the corner of the eave closest to the viewer.

8 Extend the ridge pole in back (L), but make it a little shorter than (I). Draw a diagonal line parallel to the edge of the gable in back, running from (L), well past the corner of the building.

Draw an extended dotted line from the right vanishing point to eave corner K. This line indicates the lower edge of the roof and also marks the corner of eave L.

With the guidelines erased, your house should look similar to this one.

113

Create Evenly Spaced Windows

Drawing a house or other building in perfect perspective is a great start, but all your work may be in vain if the spacing of the windows and doors is out of kilter. Here's a foolproof method for getting these important details right.

1 To create a row of evenly spaced windows, find the perspective center of the wall by penciling a large dotted-line X from corner to corner. Draw a solid vertical line where the legs of the X cross.

2 Erase the large X you drew in the first step. Use the same method to divide the wall into four sections. Draw solid vertical lines through the centers of the two new dotted-line X's.

3 Erase the two X's you drew in step 2. Find the center of each of the four sections using dotted-line X's and draw a solid vertical line through each of them. These new lines mark the center of each window.

A B

4 From this point you can estimate where the side of each window would be located, keeping in mind that the side closest to you always appears slightly larger. See the three windows toward the back of the house above. If you would rather plot where the sides of the window should be, draw X's through the newly formed sections, as shown in A and B. Where the legs of the X cross, that's the side of one of the windows. Now that you have them accurately spaced, the windows can be made uniformly wider or narrower if desired.

5 Figuring the perspective angles for the tops and bottoms of the windows is easy—just run extended dotted lines from the upper and lower edge of the nearest window to the vanishing point located on that same side. If your house needs a door, just extend the lines of one of the windows to the ground.

PERSPECTIVE ODDS AND ENDS

The principles of perspective extend to many different subjects, shapes and sizes. Here are a few examples of perspective problems you may encounter.

Sets of parallel lines that do not correspond to a horizontal ground plane, like the same-side gable edges of A and B on the house sketch below, have an oblique vanishing point. To find the oblique vanishing point relating to the pitch of the roof, run an extended dotted line upward from the near side of gable B. Next, locate the vanishing point for the side of the building supporting gable B, and extend a vertical line upward. Where the two lines cross is the oblique vanishing point. Use it as a pivot point to plot the angle of the back gable edge (A).

This is an alternative to drawing through to find the hidden walls, corners and gable edges of a building. Or you could simply estimate the angle of the back gable, keeping in mind that it will be slightly less steep than the front edge.

Oblique vanishing point

LVP

RVP

A

B

To establish an evenly spaced line of fence posts, begin by drawing the first post in the foreground (C). Pick a vanishing point for your fence line and run three extended dotted lines from the top, middle and bottom of the post to that vanishing point. Decide how wide you want the spacing between the posts to be and draw in a second post (D) down the row. Make sure that post D fits snugly between the extended guidelines. Run a diagonal line from the top of post C, through the middle of post D, ending on the bottom guideline. Where it touches the bottom line is the spot for the next post. Continue as shown in the diagram, making sure that you draw each post a little narrower as you continue down the line.

C

D

Drawing a rectangle in perspective can help you visualize a circle or ellipse in perspective.

THREE POINT PERSPECTIVE

When buildings are quite tall and are viewed from ground level like the cathedral sketched in ink below, the vertical sides of the structure appear to lean inward. If you extend those lines upward, you will see that they are actually merging toward a vanishing point located high above them. This is called *three point perspective*. Artists often exaggerate the leaning walls to give towers and skyscrapers a greater illusion of height.

When tall buildings or objects are looked down upon from over head, they appear to narrow toward their base. This is three point perspective in reverse. As you can see in the pencil sketch of the old stone font at right, the extended lines running from either side of the base will merge near the bottom of the page.

When buildings are only one or two stories high, such as the farmhouse in the photo above, inward leaning walls can look awkward. It's best to draw the sides of short structures using straight vertical lines.

COMBINING STRUCTURES FROM DIFFERENT SCENES

You can combine buildings and other manmade structures from different scenes into one composition and still keep them all in perspective. However, first you will need to find out how each one relates to its horizon line.

Consider the three buildings diagrammed below. To find the horizon line for each one, I ran extended dotted lines from the side wall and roof ridge until they crossed. Knowing that the vanishing point rests on the horizon line, I can determine where it is in each little sketch. I marked it as a solid line so I could see where it crossed behind each building.

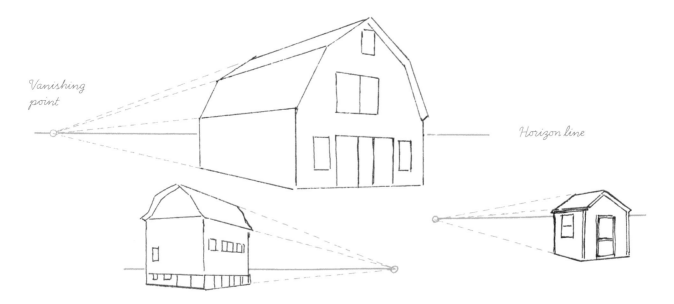

Vanishing point

Horizon line

As I arranged the buildings in my combined drawing below, I made sure that each structure related to the horizon line in the same manner as it did in the preliminary sketches. The structures can be enlarged, made smaller or moved to the right or left, as long as they are situated in the correct position on the horizon line. Keep in mind that some buildings may be well above or below the horizon line and you may have to add a hill or valley in order to use them.

CORRECTING PERSPECTIVE ERRORS

Once you are familiar with the basic principles of perspective, you can keep them in mind while sketching freehand and avoid a lot of errors. However, if the box, bridge or building begins to look a little off kilter as it develops, you can use linear perspective to make a quick check.

Run a set of extended parallel lines from both sides of the structure, making sure to include the area where the problem seems to be. If one or more of the lines do not meet at a single vanishing point, you have located the problem.

Consider these preliminary sketches for the old railway ore car. Figure A has a problem. When the parallel lines at the top and bottom of the right side of the car are extended, they remain parallel and do not merge toward each other. In Figure B, the error has been corrected.

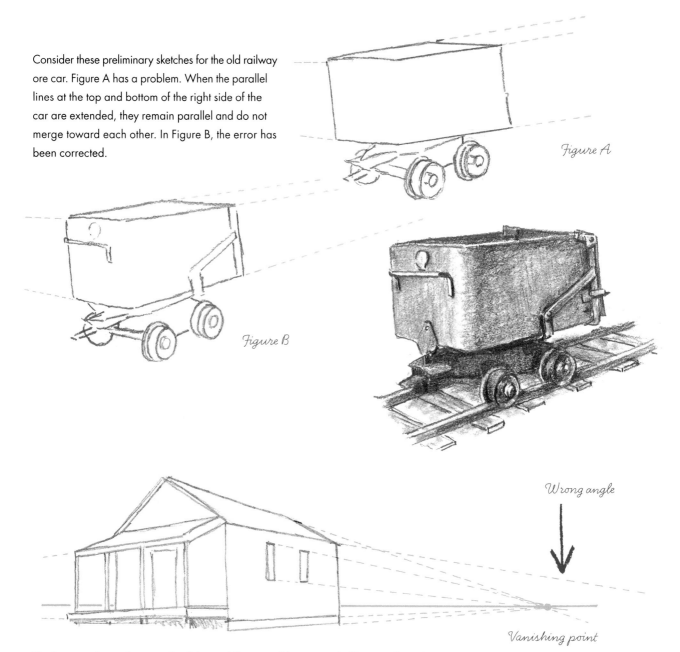

Figure A

Figure B

Wrong angle

Vanishing point

The house in this preliminary sketch has a different problem. Extended lines on the right side of the building reveal that the lower edge of the roof is angled wrong. It does not meet at the same vanishing point as the other lines running parallel to each other and the ground plane.

118

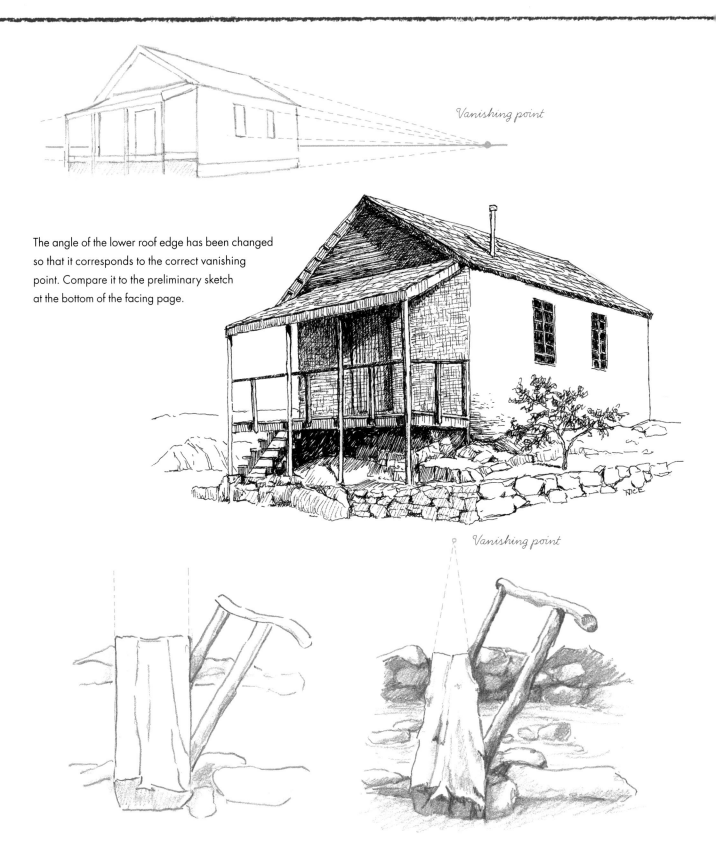

Vanishing point

The angle of the lower roof edge has been changed so that it corresponds to the correct vanishing point. Compare it to the preliminary sketch at the bottom of the facing page.

Vanishing point

Extended lines show that the sides of the log footbridge do not appear to converge towards each other as they recede into the distance. Also, the farthest hand-rail post does not seem much narrower than the one closest to the viewer.

Both perspective problems have been corrected in this sketch of the log footbridge.

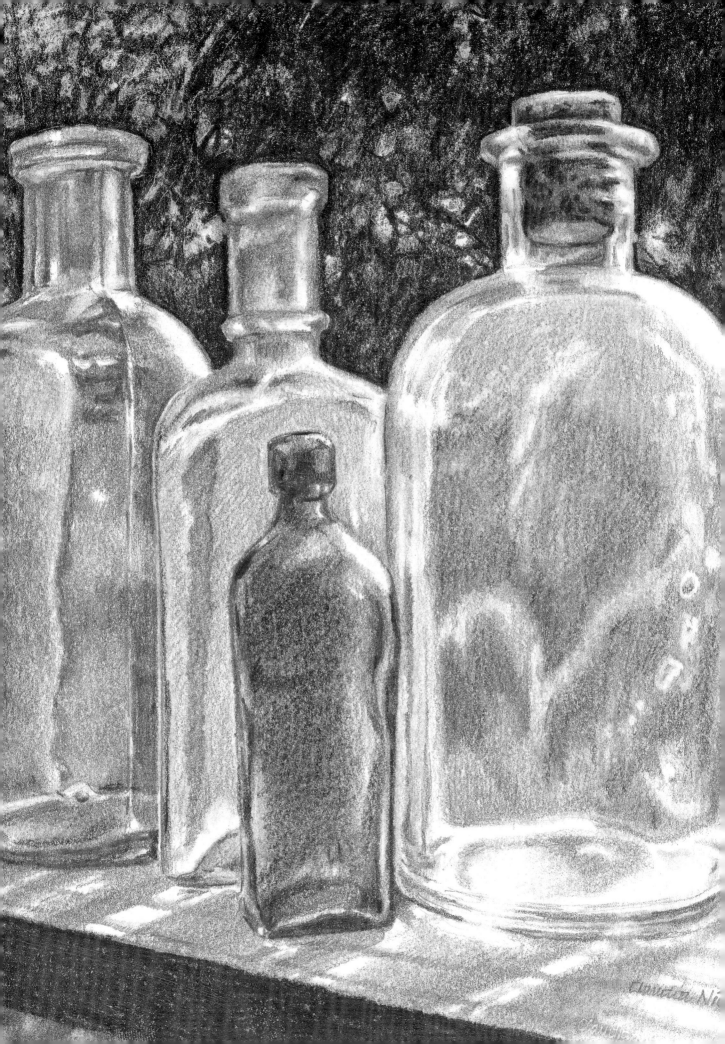

7 Revealing Form through Light and Shadow

A drawn shape appears flat until the presence of light and shadow is suggested across its surface. It's the various lights, shadows and value changes that describe the contours of the object to the viewer. Consider the line drawings of the bottles at the bottom of this page. Their basic shape has been well established and they appear to be transparent, but their volume is merely hinted at by a few interior lines. Compare them with the more detailed drawing at left. With the introduction of lightplay across the surface of these bottles, we can enjoy the fullness of their form. In addition, we can better understand their character: the sparkle of sunlight denotes a polished surface, while the soft, blended value changes suggest a rounded exterior. The way the light shines through the glass walls and glints across the cast shadows leaves no doubt that these are transparent objects. Note that they are not outlined, but the edges are boldly and naturally defined using contrast of values—light against dark and vice versa. All of these light and shadow techniques work together to make the glass bottles glow with the illusion of reality.

I have spent countless hours observing nature to see for myself how light and shadow "partner-up" in different situations, for you can't have one without the other. Sometimes the questions have been overwhelming and I've turned to science and math experts for the answer. For example: how do you plot a cast shadow accurately on an overcast day? It can be done and I'll show you how within the pages of this chapter. So if you're inquisitive like me and have ever wondered how to simulate the illumination of light as it passes through a water drop or how manmade light differs from sunlight in the shadows it casts, I invite you to take a stroll with me to find the answers.

Old Bottles on a Window Shelf (opposite)
Pencil drawing using 4B - 7B pencils on drawing paper.

Values

Value is the relative lightness or darkness of a color or tone. As you can see in the value charts below, the marks created by pens and pencils are capable of creating a full range of value tones.

Contrast of value enables us to see edges and images clearly. The greater the contrast between light and dark, the sharper the image will be and the more impact it will have on our visual sense. Strong contrasts are bold and exciting and can be used to focus our attention on centers of interest. Low light, shadow areas provide poor value contrast and form definition, but make great backdrops for the more important parts of the composition. Note the difference in visual impact in the squares and circles shown below. As the value contrast lessens, definition is lost.

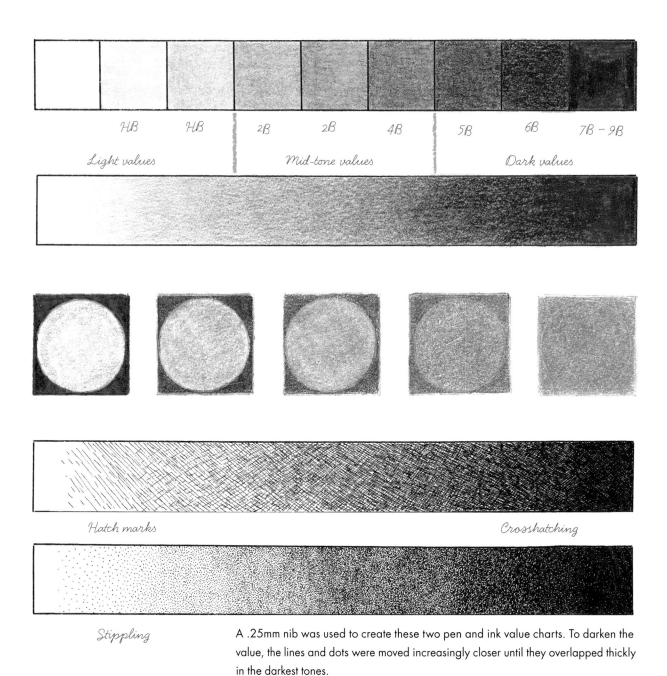

HB HB 2B 2B 4B 5B 6B 7B – 9B

Light values Mid-tone values Dark values

Hatch marks Crosshatching

Stippling A .25mm nib was used to create these two pen and ink value charts. To darken the value, the lines and dots were moved increasingly closer until they overlapped thickly in the darkest tones.

STUDYING **LIGHT–PLAY**

The best way to learn how light and shadows function when introduced to the surfaces of different forms is through direct observation. Gather objects like the ones below from around the house and set them on a large sheet of white paper. Turn out all the lights, pull the blinds and use a single bulb light source to experiment with. Changing the height and direction of the light will give you a great variety of shadows to study and sketch.

Here is a list of the light-play elements to look for in each setup.

Highlight: An area of intense light reflected off the surface of a form. Highlights are direct reflections of the light source and are most prominent on smooth, high-gloss surfaces.

Form shadows: Darker value areas occurring on those portions of an object that are turned away from the light source. The core shadow is the darkest portion of the form shadow and receives the least amount of light.

Reflected light: An area of lighter value cast on the dark side of an object as a result of light bouncing off another surface. Reflected light is less intense than direct light.

Cast shadow: An area of darker value created when an object blocks the direct light from falling on another surface. Cast shadows reveal the contours of the surface they rest upon, but rarely describe the object that cast them with accuracy.

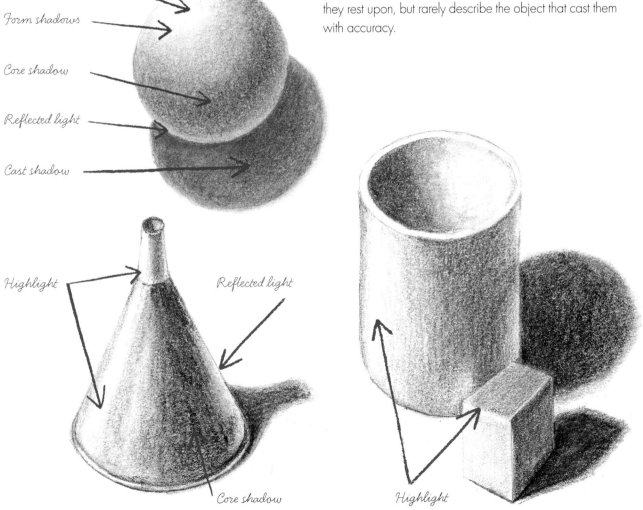

Highlight

Form shadows

Core shadow

Reflected light

Cast shadow

Highlight

Reflected light

Core shadow

Highlight

LIGHTS, SHADOWS AND **SURFACES**

The appearance of light-play over the surface of an object is affected not only by the contours of that object, but also by its texture. On smooth, rounded surfaces, like the surface of the egg sketched below, the transition from the light side to the dark side is a gradual blend of values. Smooth surfaces gather light and reflect it very effectively. Highlights are strong and reflected light areas are quite noticeable, although they are never as bright as the surfaces receiving direct light. To add a little more sparkle, a white charcoal pencil was used to brighten the highlights on the egg, sea shell and button.

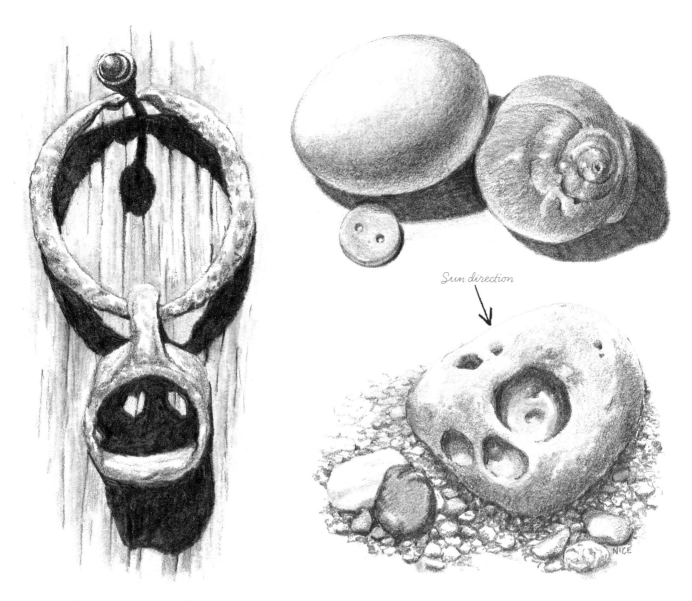

Sun direction

Rounded surfaces that are rough like this rusty metal piece make a choppy transition from light to shadow. Using a blunt-edged pencil and creating little patches of varied tones will suggest the uneven surface. While the light side of the rough object may be bright, you will not see strong, glinting highlights. This rusty bit of metal is the end piece of an old double-tree wagon hitch. I found it hanging on the side of a barn. The cast shadows were wonderfully bold.

Abrupt edges are suggested by abrupt value changes. Note the value change along the upper edge of each hole in the beach rock above. The hole is the darkest against the light side of the rock and the edge is lost (fades out) on the opposite side.

Polished metal reflects more than light. It readily picks up colors, value tones and images, and reflects them like a mirror. If the surface is curved like the metal bowl sketched below, the images will be distorted into tonal stripes. While the form shadows follow the contour in a gradual change of values, reflected tones and images often have abrupt edges and strong value changes. Areas receiving the strongest direct light will glint in a sparkle of strong white light.

Soft, pliable materials like tender leaves, fabric and human skin tend to have folds, wrinkles and puffy areas. These are suggested with gradual value changes in the folds and swells, and abrupt value changes in the wrinkles. Notice the indentions and swells in the finished drawing of the ginger leaf. The sides of the swells away from the light are dark and the opposite sides are light. Note that there are no harsh lines drawn in between.

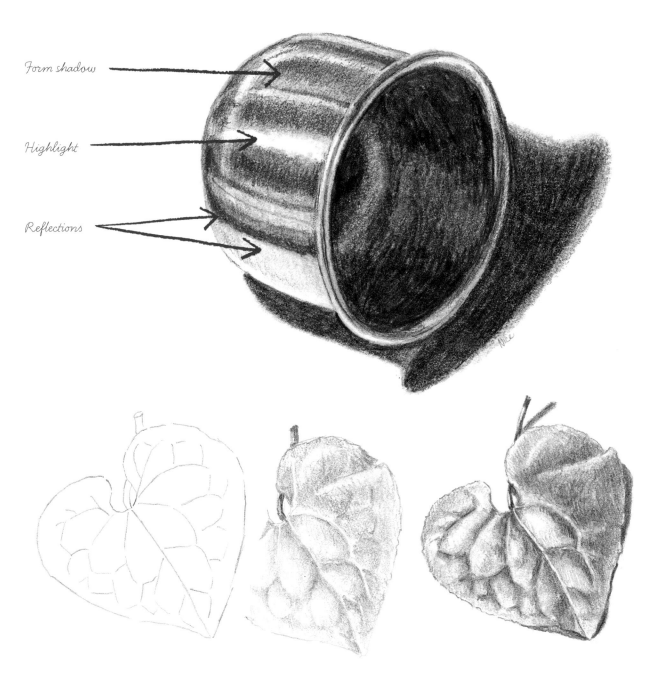

Form shadow

Highlight

Reflections

Preliminary sketch

Preliminary shading

Core shadows added

125

DEVELOPING THE **VALUES**

After your preliminary sketch, begin developing the form shadows in the darkest areas first, using mid-tone to light-tone grays, as shown in Step 2. Shadows can always be made darker, but it's hard to lighten heavily worked shadows and keep the area crisp and clean. Once the dark shadow areas are established in light gray, they can be gradually darkened by using more hand pressure, layering, or using a softer pencil lead. As the areas are darkened, blending stumps or tortillions can be used to smear light-tone grays into the paler portions of the drawing as shown in Step 3. Care should be taken not to overrun the highlight areas that are to remain paper-white. Should that happen, a kneaded eraser, pinched to a ridge, is useful for retrieving small white areas lost in "gray-tone smear."

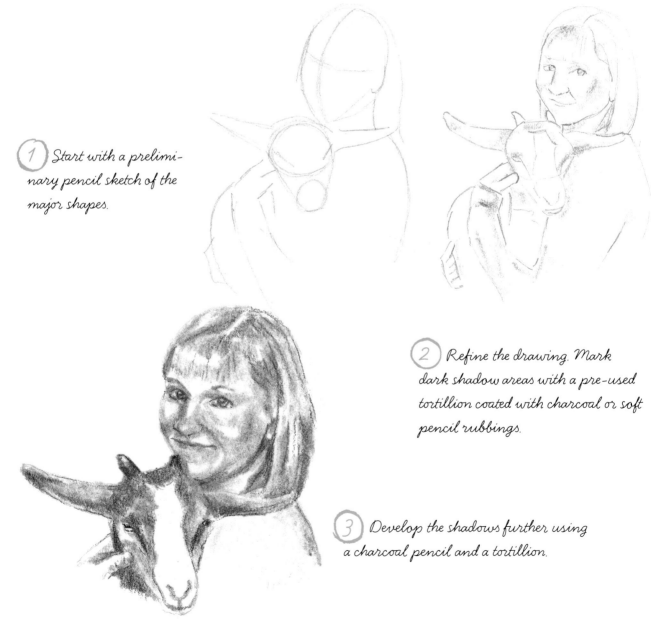

1 *Start with a preliminary pencil sketch of the major shapes.*

2 *Refine the drawing. Mark dark shadow areas with a pre-used tortillion coated with charcoal or soft pencil rubbings.*

3 *Develop the shadows further using a charcoal pencil and a tortillion.*

④ Finish the drawing using charcoal pencils and blending with tortillions or a blending stump.

At the County Fair
2B pencil and 2B and 4B charcoal pencils on drawing paper.

Depicting Transparency

GLASS OBJECTS

When drawing and shading a glass object, there is more to consider than how the light moves over its outer surface. Since it's transparent, the contours on its far side will also show, along with anything directly behind it or inside of it. Curved glass objects distort the shape of anything seen through their walls, causing the objects to ripple or look disconnected, like the pair of scissors in the pen and ink drawing (below left). Multiple shapes, colors and value tones are picked up from surrounding objects and reflected in the polished surface. Often these reflections have abrupt edges. I find it helpful to map them out lightly in pencil before I start the shade work, as shown at right in the preliminary sketch of the bottles.

Delicate contour ink lines, drawn with a .25mm nib or smaller, work well to suggest the exterior shape of a glass vase or bottle.

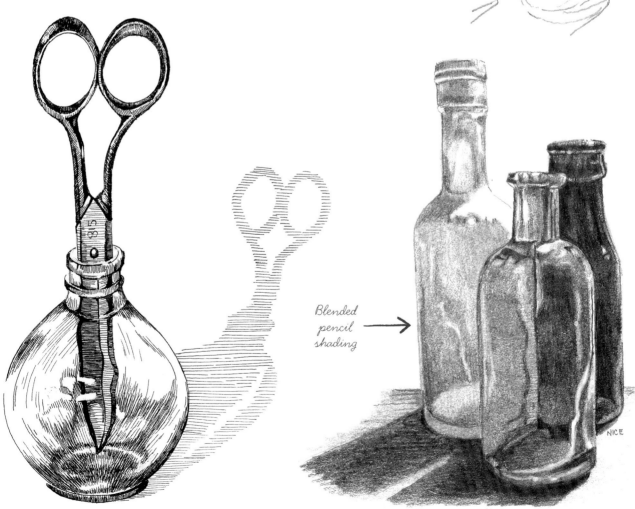

Blended pencil shading →

ORB-SHAPED OBJECTS

When strong light strikes a transparent, orb-like object, some of the light bounces back in the shape of the light source. The highlight spot may be round like the sun, rectangular like a window or there may be several of them shaped like long fluorescent light fixtures. The rest of the light travels through the orb and spreads out (see the eye diagram below). It will exit at the opposite side from where it entered, forming an illuminated crescent. As seen in the water droplets and glass marble, a cast shadow forms behind the crescent of illumination, making it seem even brighter.

The eye is orb shaped, but much of it is covered by the eyelids. If the light is coming from above, a shadow is cast across the upper part of the eyeball by the eyelid. This shadow is important, because it sets the eye back behind the upper lid and makes it appear rounded. The eyelids have a bit of thickness to them and should be drawn with a rounded edge. This is where the eye lashes are rooted. The area directly above the lower eye lid is moist, and may show tiny, reflective highlights.

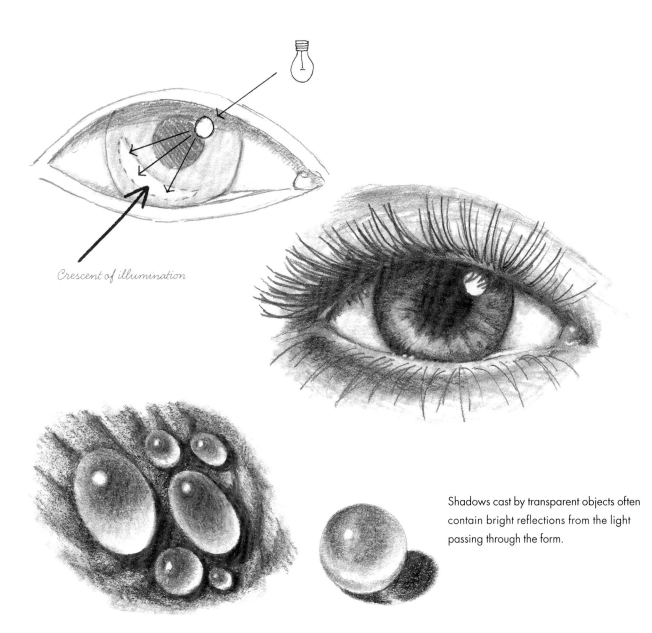

Crescent of illumination

Shadows cast by transparent objects often contain bright reflections from the light passing through the form.

Plotting Cast Shadows

SUN-CAST SHADOWS

The best way to create cast shadows is to draw them from life; however, light, especially sunlight, is unreliable. The first step in developing believable sun-cast shadows is to decide which light direction you wish to use. The light direction determines the shadow direction. Shadows cast by the sun run parallel to each other due to the fact that the light source is so far away.

The light direction is determined on the ground plane. To see the full range of light direction choices, we need an overhead view (Figure 1, right). The arrows in the chart represent some of the possibilities. I chose the circled arrow from the chart and duplicated its position on my drawing surface, making sure I drew the arrow long enough that I could see its angle clearly. The angle of the light direction arrow (LD) is the same angle I will use to draw in the shadow direction lines (SDLs).

Figure 1

Light Direction Chart

Barn

Silo

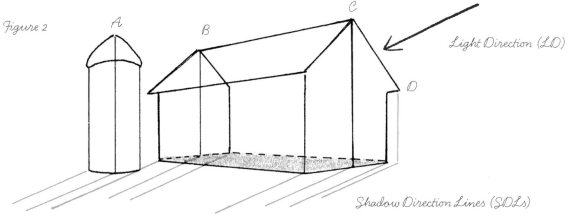

Figure 2

Light Direction (LD)

Shadow Direction Lines (SDLs)

The shadow direction lines are drawn from those corners of the barn and the outer edges of the silo that touch the ground, including the hidden corner (Figure 2, above). A line should also be dropped to the ground from each of the highest positions in each structure (A, B and C) and the overhanging eave (D). Shadow direction lines are also drawn from those points. All of the shadow direction lines should run parallel to the light direction arrow and to each other.

When light comes from directly behind the structures, the shadow lines run straight down (Figure 3, right).

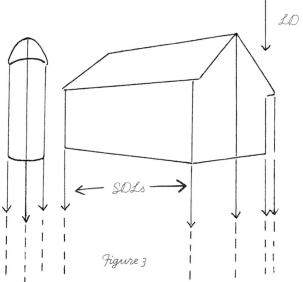

LD

SDLs

Figure 3

130

The length of the cast shadow is determined by the sun's position in the sky. The closer the sun is to the ground plane (horizon), the longer the shadows will be. The light source (LS) is always located directly above the light direction (LD). Locate the purple light-direction arrow in Figure 4. A dotted line has been drawn vertically upward from the tail of the purple arrow, with several sun symbols placed along it at different heights. A black arrow has been extended from each sun symbol toward the pointed end of the purple light-direction arrow. These black arrows represent the angle of the light as it travels from the light source towards Earth. The angle gets steeper as the sun symbols get higher.

I have chosen the second sun symbol from the top as my light source. To determine the outer perimeter of the shadow cast by the barn and silo, I ran extended diagonal lines from the top corners and peaks of the structures, duplicating the angle of the black arrow connected to my light source. These are represented by dotted lines in the diagram. Each dotted light source line will intersect with its corresponding shadow direction line. These intersections mark the edge of the cast shadow and just have to be connected like a child's connect-the-dots drawing. The shadows formed by the hidden corner of the structure or the back gable are ignored unless they extend past the back wall of the building as shown in Figure 5.

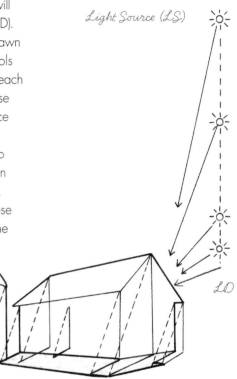

Figure 4

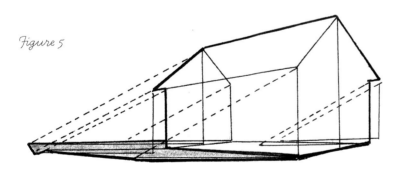

Figure 5

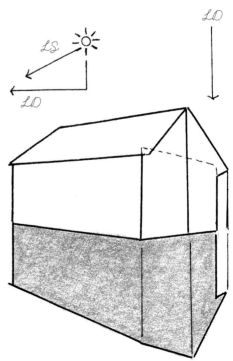

When the light direction is precisely behind the building and the light direction arrow runs straight down, placing the light source above it would only produce more straight arrows. I solve the problem by drawing a mirror image of the structure and lengthen or shorten the shadow according to the time of day. Mid-day equals short shadows. Dusk equals long shadows.

Build a simple mock house out of a small jewelry box and a stiff piece of paper folded into a roof shape, such as the one at right. Secure it together with tape and take it out into the sunlight to see what kinds of shadows it casts. Sketch or photograph the results as a visual reference.

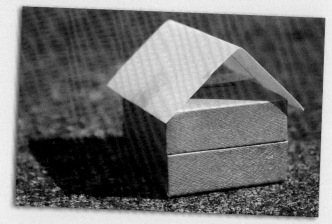

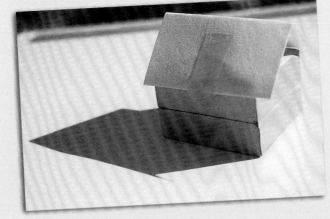

Paper roof is on crooked. Ridge pole is not centered.

Hidden eave corner

Hidden corner of back wall

On a flat, smooth surface, under ideal lighting conditions, the mock house will cast a shadow that looks exactly the same as one plotted on paper. Compare the photo above with the diagram at right.

LS

LD

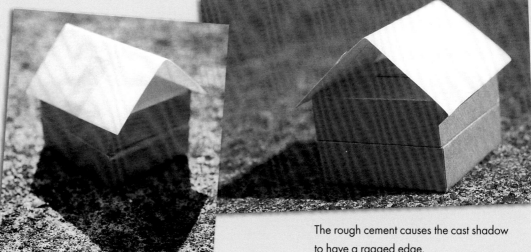

Reflected light bouncing off a snow bank behind the mock house caused the shadow lines to radiate outward instead of dropping straight down.

The rough cement causes the cast shadow to have a ragged edge.

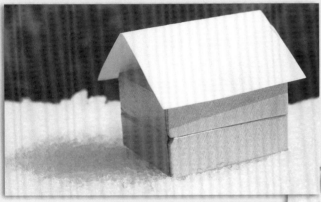

The moss on this rock catches the light and obscures the edge of the shadow in much the same way as a stand of tall grass would. Note how much darker the shadow on the moss is compared to those on the white surfaces.

In strong sunlight, a smooth, light colored surface will produce hard edged shadows.

Compared to the small size of the mock house, the frozen snow crystals are like large translucent rocks. The edge of the cast shadow is indistinct due to the uneven ground and the reflected light.

Cast shadows do a good job of describing the terrain lying under them. Both of these mock houses are placed on snowy hillsides. Note how the shadows they cast curve downward, following the slope of the land. Observe how the "tree shadows" cast across the top of the house at left travel upward and then abruptly down as they pass over the ridge of the roof.

MAN–MADE **LIGHT** AND CAST SHADOWS

Shadows resulting from man-made light sources, whether from light bulbs or firelight, move away from the light in all directions, radiating outward from the objects that cast them. This is because man-made light is so close to the objects it affects, compared to the great distance of the sun from the Earth.

Plotting the shadows resulting from man-made light sources is similar to plotting sun-cast shadows (described on pages 130-131), with one major exception. Dots are used to represent the light direction (LD) and light source (LS) rather than arrows, and lines are drawn from those dots to the appropriate corners of the subjects, as shown in Figures 1 and 2 below.

The light direction (LD) is selected from a location on the ground plane and represented by a dot. Shadow direction lines are extended from the dot, past those corners of each object that touch the ground. If the object has a high center or changes width part-way up, like the middle jar, additional lines need to be run from those points to the ground and included when plotting the shadow direction lines.

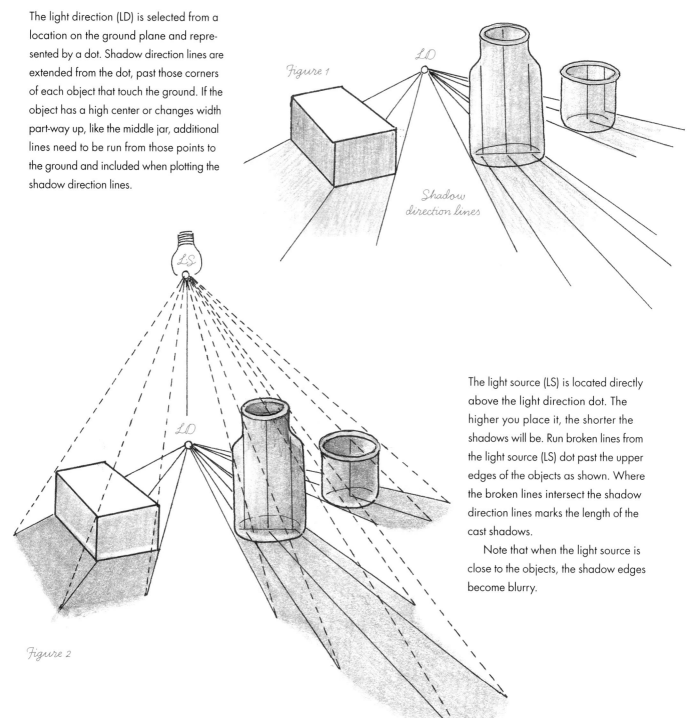

Figure 1

LD

Shadow
direction lines

Figure 2

LS

LD

The light source (LS) is located directly above the light direction dot. The higher you place it, the shorter the shadows will be. Run broken lines from the light source (LS) dot past the upper edges of the objects as shown. Where the broken lines intersect the shadow direction lines marks the length of the cast shadows.

Note that when the light source is close to the objects, the shadow edges become blurry.

134

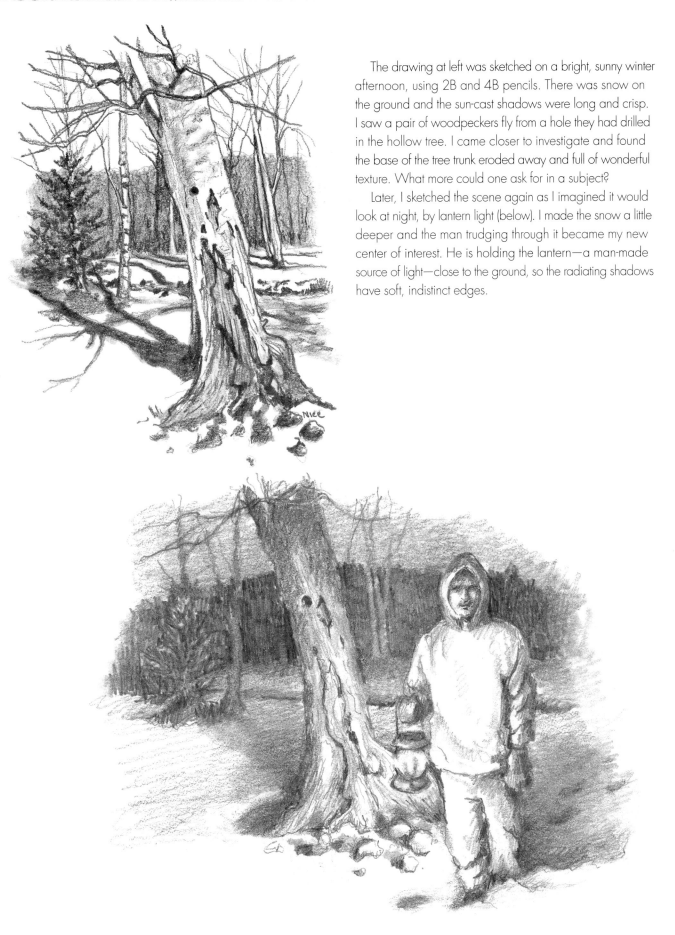

The drawing at left was sketched on a bright, sunny winter afternoon, using 2B and 4B pencils. There was snow on the ground and the sun-cast shadows were long and crisp. I saw a pair of woodpeckers fly from a hole they had drilled in the hollow tree. I came closer to investigate and found the base of the tree trunk eroded away and full of wonderful texture. What more could one ask for in a subject?

Later, I sketched the scene again as I imagined it would look at night, by lantern light (below). I made the snow a little deeper and the man trudging through it became my new center of interest. He is holding the lantern—a man-made source of light—close to the ground, so the radiating shadows have soft, indistinct edges.

ANCHORING THE SUBJECT

Cast shadows make great anchors to declare just how a subject relates to whatever is beneath it. In addition, the cast shadow can help describe the shape and texture of whatever is below. For example, look at the pencil drawing of the boy on the slide. Without anything beneath him, the boy would be in a very awkward position. However, when the unbroken shadow is placed under him, it suggests that he is sitting solidly in place, on a steep, diagonal object. The cast shadow follows the contours of the slide and helps the viewer determine what it is.

Cast shadows can also reveal when the subject is not touching the ground. Study the stippled ink drawing of the trotting horse. Note how the open gaps between the hooves of the horse and the shadows they cast inform the viewer that the feet are in the air. They also tell how high they are raised. Without the ground shadow, this information would be lost, and the animal would appear to be floating.

WATER **REFLECTIONS**

Water has the reflective qualities of a mirror. The clarity of the reflected image depends upon the water and lighting conditions. Under ideal conditions, the sun shines brightly and directly on the subject. As the light bounces back, some of it reaches the viewer and presents him with a direct image of the subject.

If a portion of the reflected light hits a still body of water, some of it will bounce back toward the viewer and present him with an upside-down image of the subject.

In fairly still water, the reflected image should appear directly below the part of the subject that cast it, as shown by the dotted lines in the sandpiper sketch at right.

If the body of water is rippled, the image will be broken and distorted, as shown in the drawing of the pintail duck below. The ripples may carry part of the reflected image out from under the subject.

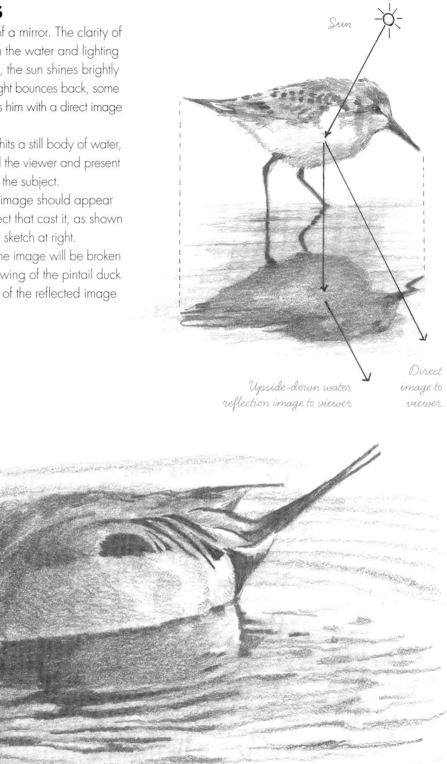

Sun

Upside-down water reflection image to viewer

Direct image to viewer

137

CREATING DRAMATIC **IMPACT**

We see natural edges best when they contrast with their background. The stronger the contrast, the more distinct the edges become. White against black is bold, grabbing the attention of the viewer. Strong, brightly lit areas reveal the form and texture of the subject, while deep, darkly shadowed areas are cloaked in mystery. If one is set against the other you have the makings of a dramatic drawing.

The seascape drawing above is rendered mostly in restful tones of gray. A loose, scribbled outline was used to reinforce the frothy edge of the breaker. On the whole, the drawing is rather bland, with little to keep the viewer's attention.

The drawing of the same subject, seen below, has a full range of values. Strong value contrasts were used to mark abrupt edges, while gently blended value changes were applied to give the breaking wave and frothy spray a translucent quality. The black shadows inside the wave lend strength, drama and a touch of the unknown to the scene.

2B pencil

HB, 2B and 4B pencils

Tara By the Window (opposite)
In this portrait drawn with 2B, 4B and 6B pencils on drawing paper, strong value contrasts and a variety of soft edges, hard edges and lost edges were all used to catch and hold the viewer's interest. Note how one side of her face melts into the deep background shadow, adding a touch of intrigue.

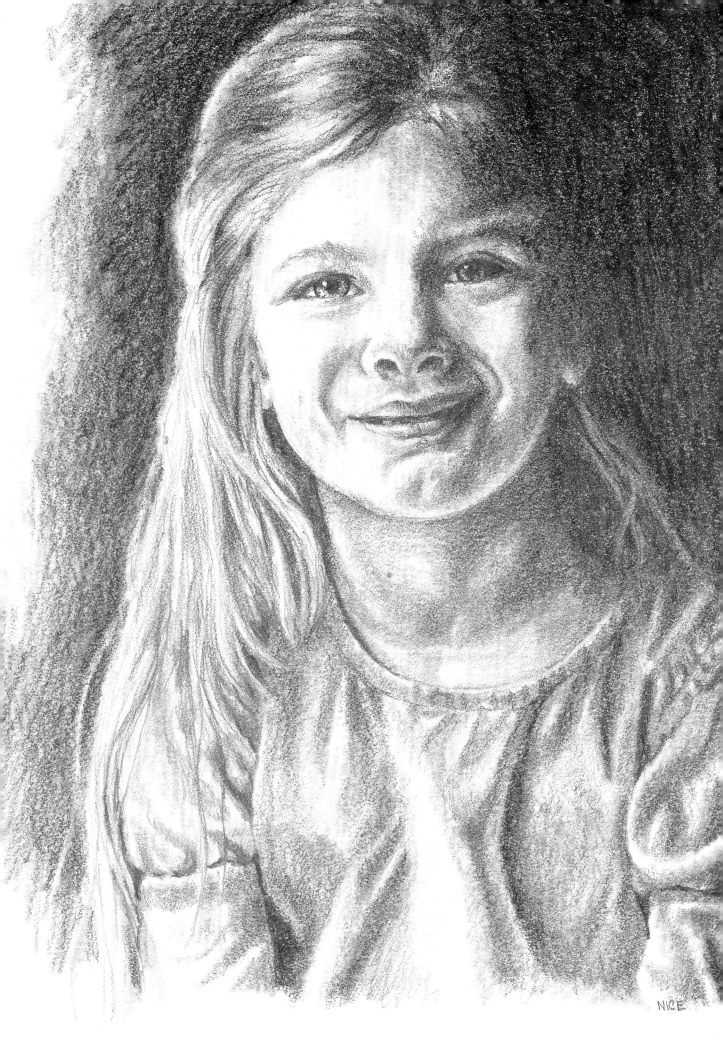

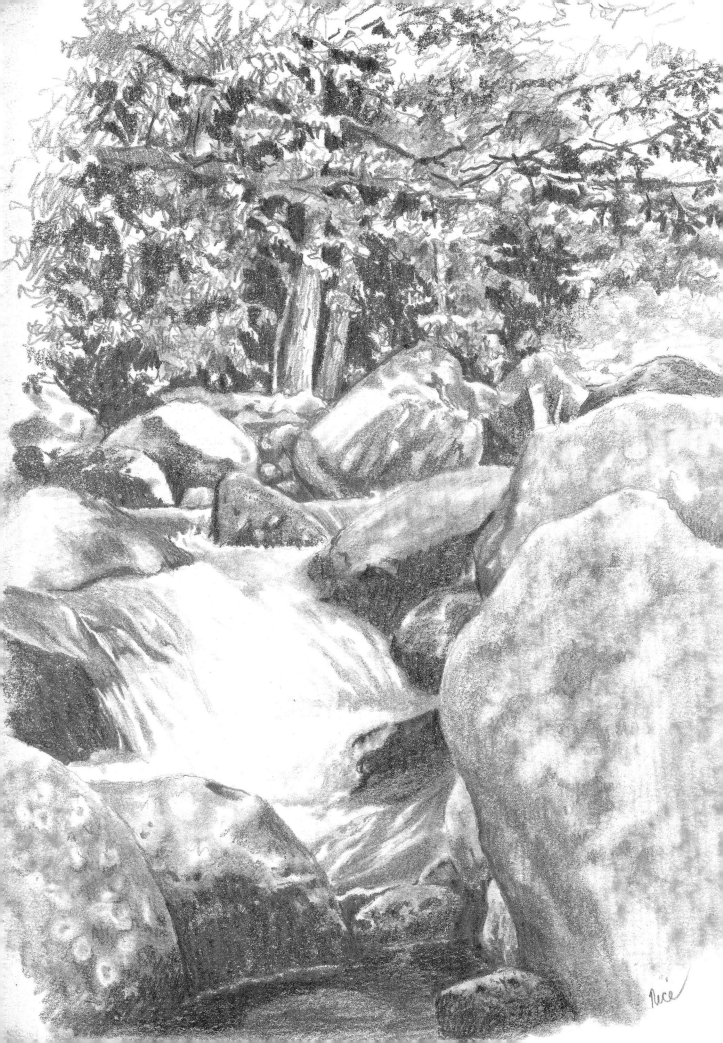

8 Creating Texture and Energy

In the previous chapters, we have talked about shape, form and shadows. Those elements are the body of the drawing. This chapter will show you how to simulate surface texture. It's like the frosting on a cake. Plain cake is good, but cake with a layer of thick, rich, frosting is much more likely to grab your attention. It not only appeals to your eyes, but your other senses start to appreciate it even before you take that first bite. Just as there are many types of frosting—plain, sculpted or roughened with chunks of chocolate, nuts or sprinkles—there is a great variety of simulated surface textures that can be achieved with a pen or pencil.

Consider the pencil-drawn landscape on the facing page. It is full of simulated texture. The clumps of tree foliage in the background are densely layered and entwined. It's the scribble lines that give them the thick, lacy appearance, and the blended values that make them look more like leaf clumps than tangled wire.

The water-worn boulders in the scene were actually textured using a real stone. I used a piece of rough, semi-flat lava rock under the drawing paper and rubbed the texture into place using a soft pencil and a paper stump. The white lichen patches were rubbed out using a gum eraser. Having free reign with your imagination is part of the fun of the texturing process. If it works, it's legal, and causes no harm, go for it.

Sometimes it's what you don't add that suggests texture. Note that the frothy whitewater is neither outlined nor heavily shaded with pencil. A graphite-coated paper stump was used to rub just a hint of water movement into the shadow areas of the waterfall. The more white of the paper you leave, the crisper and purer the falling water looks. Set against the black rock shadows, the pale, cascading water has more than simulated texture, it has strength, movement and energy.

Walker Creek
Pencil drawing using 4B - 7B pencils on drawing paper.

Developing Textures

SMOOTH TEXTURE

Creating a smooth surface texture in pencil or pen is not as easy as it might seem. The drawing paper itself has texture and as the blunt edge of a soft pencil is rubbed over it, it catches on the high points of the paper and darkens. As you can see in the example at right, this texture looks more rough than smooth. Rubbing it aggressively with a heavy paper stump can smooth it out quite a bit. However, for the smoothest look, start with a used paper stump that has a good coating of graphite already on it and use it to rub on a smooth undercoating (A). Press hard to flatten down the paper texture. You can pencil over the undercoat in light layers to create form shadows, blending each layer in with the paper stump (B). Achieving smooth, black shadows is not a problem. Choose a 4B or softer pencil and fill it in solidly with firm pressure. The cast shadow seen in the drawing of the cherries was done using a 7B pencil.

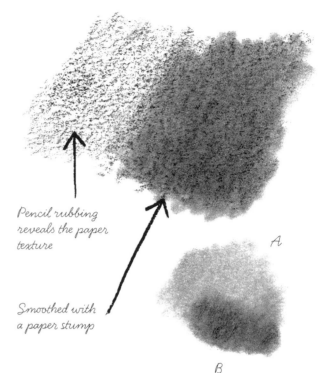

Pencil rubbing reveals the paper texture

Smoothed with a paper stump

A

B

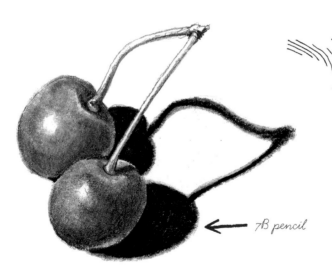

7B pencil

Contour lines

To suggest a smooth, rounded surface in pen and ink, I use a .25mm nib and contour lines. Contour lines are straight or gracefully curved strokes that are lined up side-by-side and flow over the surface of an object like a thin layer of water. The strokes can be long or short, their direction changing to follow the shape of the form beneath them. Contour lines can be layered to obtain darker values, but avoid criss-crossing them, as crosshatching will spoil the smooth look.

Contour lines work well to suggest the texture of:

* Polished, shiny objects like glass, chrome and glazed pottery
* Smooth, dull-surfaced objects like cast iron or eggshells
* Folds and wrinkles in skin and smooth fabric
* Rough textured objects seen at a distance
* The motion of waves and cascading water

The handles on the pens, pencils and paint brushes are composed of curving contour lines.

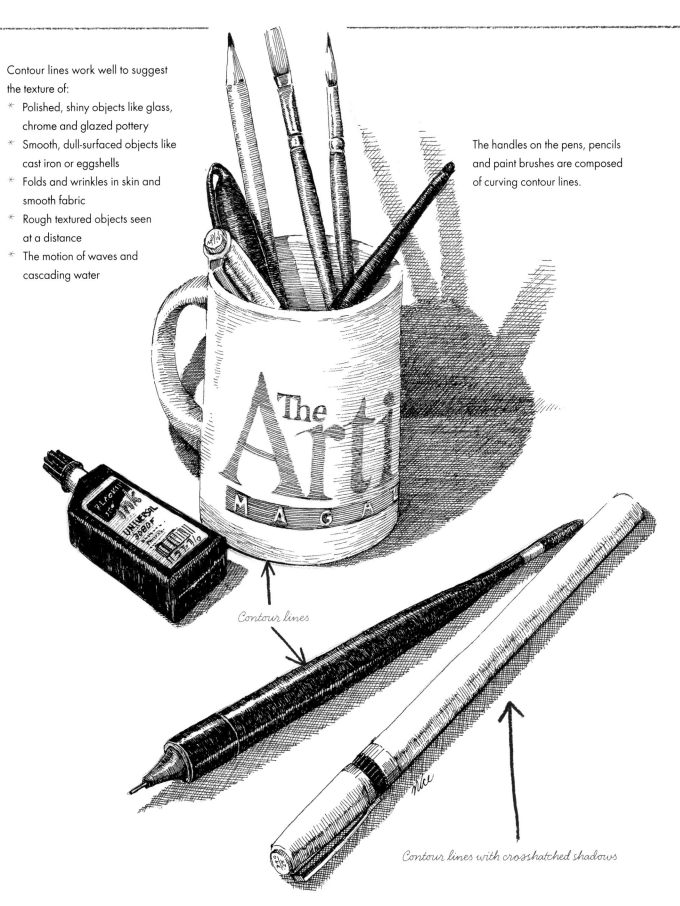

Contour lines

Contour lines with crosshatched shadows

ROUGH AND RUGGED TEXTURES

To create a rough, rugged texture, you have to loosen up your strokes and be a little haphazard. Being the opposite of smooth, the lines should cut across each other in a random, spontaneous manner, with a little scribble work thrown in for good measure. Crosshatching can provide a wide range of coarse textures. The elepahant at right was crosshatched using a technical pen with .25mm to .50mm nib sizes.

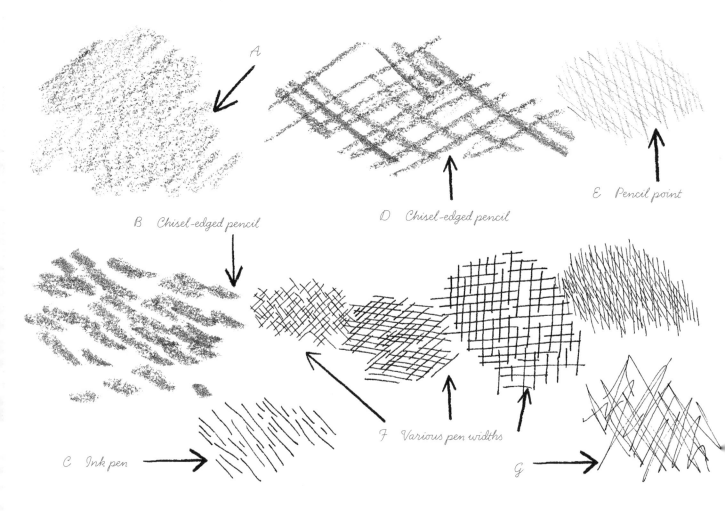

A

B Chisel-edged pencil

D Chisel-edged pencil

E Pencil point

C Ink pen

F Various pen widths

G

LEGEND

A:
Paper rubbed with a soft, chisel-edged pencil

B and C:
Hatch marks (haphazard strokes running in one general direction)

D, E and F:
Crosshatching (hatch marks that run in at least two different directions and intersect)

G:
Scribbly crosshatching

Brick wall

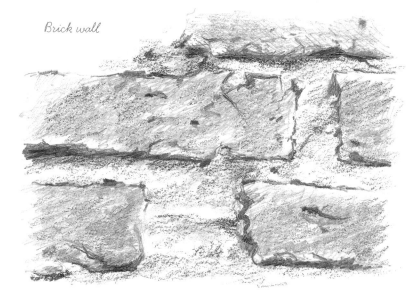

144

Crosshatching works well for:
* Craggy rocks, tree bark and other highly rough surfaces
* Thick, tough skin
* Heavy shadow areas
* Veined leaves and insect wings
* Coarse, woven fabrics and wire screens
* Lizard skin and fish scales
* Masonry

ROUGH-TEXTURED PENCIL **RUBBINGS**

A fun, creative way to add rough texture to your drawing is by transferring it directly from a rough surfaced object to your paper, using the pencil rub method. For the best results, choose a firm, textured object that does not have sharp protrusions and will lie evenly beneath the drawing surface. Place the rough surface under a thin sheet of drawing paper and rub the top surface of the paper with the side of a soft pencil lead. The pencil will catch on the raised portions of the rough surface beneath the paper and transfer a pattern.

Rock surface

4B pencil

2B pencil

7B pencil

Cedar shingle

4B pencil

Rotary sanding pad

4B pencil

2B and 4B pencils

Wire mesh window screening

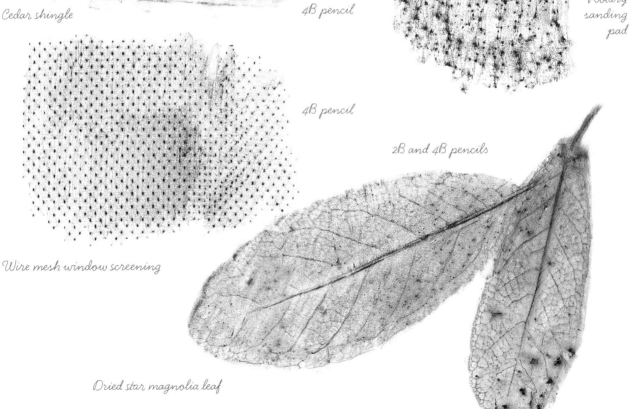

Dried star magnolia leaf

Dried magnolia leaf skeleton

In the drawing below, the skin of the toad was textured by placing the drawing paper over a sheet of heavy duty sandpaper and rubbing inside the outline of the toad with a 4B pencil. The resulting texture marks were sprayed with fixative and the shadows and "warts" were added. The texture of the log beneath the toad was transfer-rubbed from a wooden shingle and the leaf texture was transfer-rubbed from dried leaves.

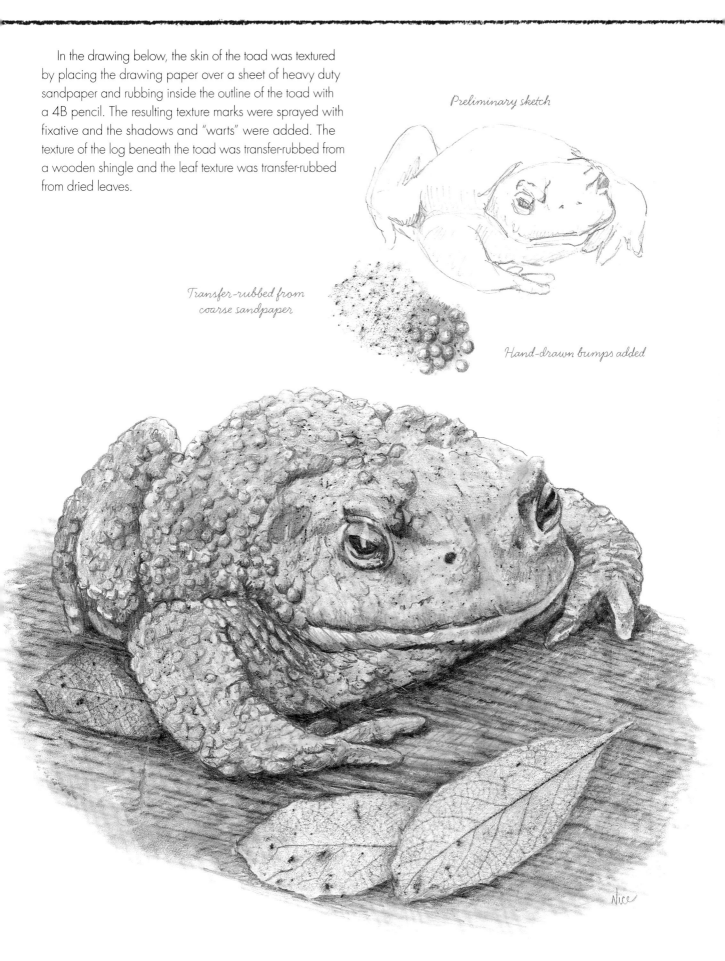

Preliminary sketch

Transfer-rubbed from coarse sandpaper

Hand-drawn bumps added

WOVEN TEXTURES

Coarsely woven materials, transferred onto the drawing surface using the pencil rubbing technique, make great backgrounds for still life scenes. Pieces of ric-rac, lace ribbons, twine, broad-toothed combs, and the tops of children's alphabet blocks also make interesting rubbed textures.

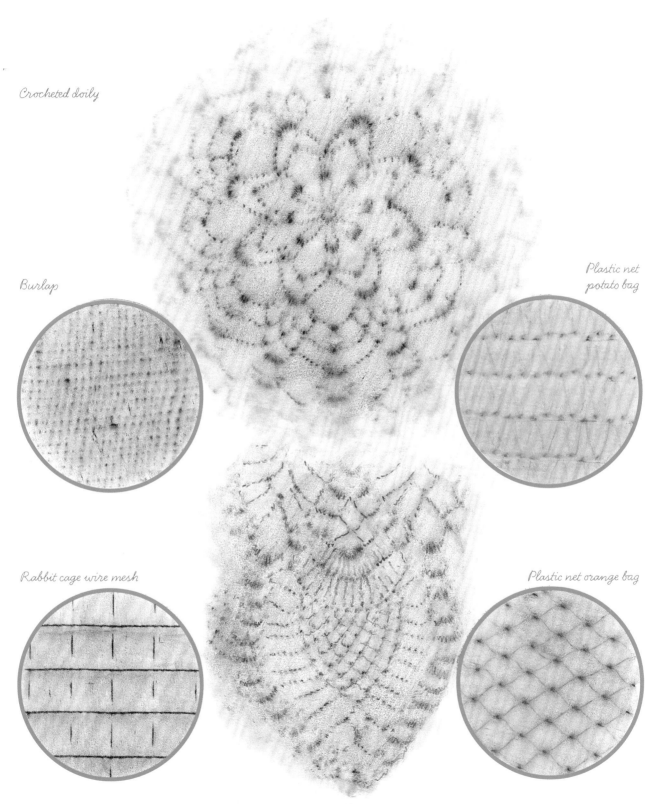

Crocheted doily

Burlap

Plastic net potato bag

Rabbit cage wire mesh

Plastic net orange bag

Crocheted lace

148

The still life drawing below was completed using 2B and 4B pencils and a paper tortillion for blending. The textured background was achieved by placing a plastic net potato bag and a piece of burlap under the drawing paper, taped in place on a hard surface, and rubbing the appropriate areas of the background with the 2B pencil.

Plastic net potato bag

Burlap

DUSTY, **GRITTY** TEXTURES

The surest way to create the look of age in a drawing is to stipple the entire piece. Stippling is merely a grouping of dots. Tiny, delicate dots look dusty as if the subject were sprinkled with the dust of time, as seen in the pen-and-ink drawing of the antique toy truck below. Large, bold dots look gritty or sandy, while short, slightly curved dashes have a flaky appearance. Long dashes are the equivalent of hatch marks.

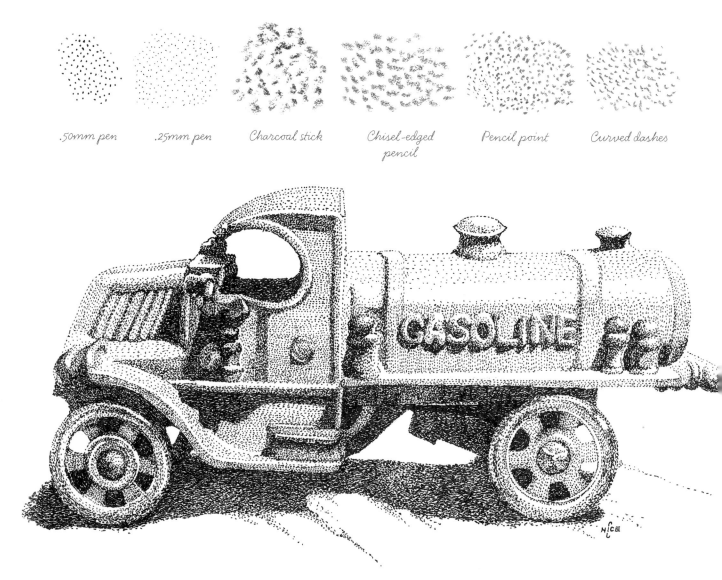

.50mm pen .25mm pen Charcoal stick Chisel-edged pencil Pencil point Curved dashes

Stippled textures work well to suggest:

* Antique or nostalgic subjects
* Dusty, rusty, gritty or sandy areas
* Objects made up of a gathering of particles such as clouds or water spray
* Bumpy areas such as the center of a daisy
* Velvety surfaces and flower petals
* Abrasive materials such as adobe or bricks
* Delicate, transparent subjects such as jellyfish

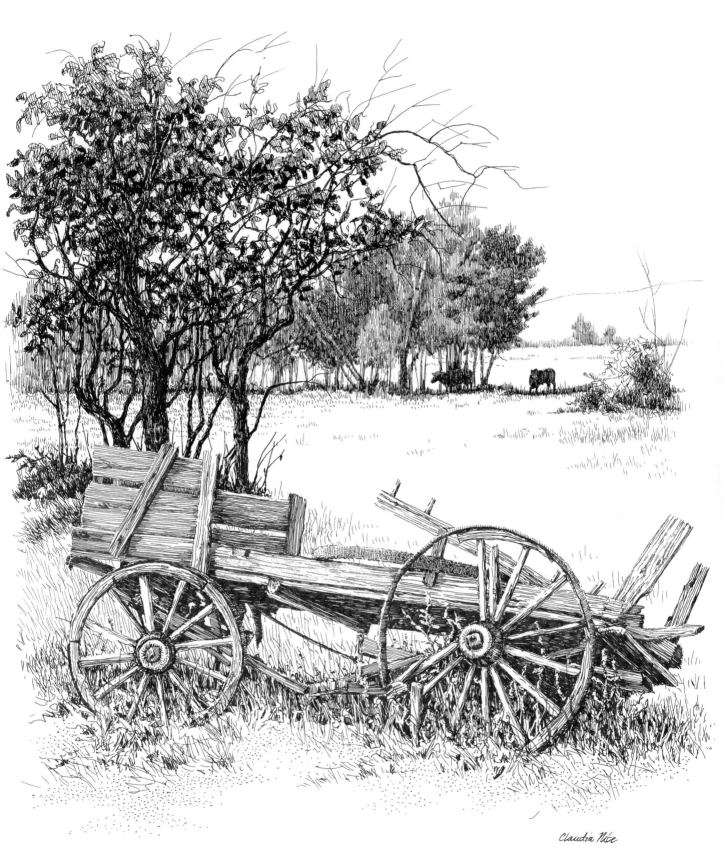

Claudia Nice

Abandoned Wagon

In this multi-textured, pen-and-ink landscape, stippling was used to suggest the gritty soil in the foreground and the rusty wheel lying in the wagon bed. Pen nib size .25mm was used for the dot work.

GRAINY, PATTERNED TEXTURES

Wood grain, marble and even the vein patterns in some leaves can be duplicated using wavy lines drawn in repetitive patterns.

Marble grain patterns tend to be arranged in streaks and cobweb-like patterns, intermingled with dark patches. Light against dark value changes are common. Agate patterns are similar, but often arranged in swirling bands with abrupt changes in color and tone.

Wood grain varies a lot in appearance depending upon the tree species and how weathered it is. In general, the wavy lines flow in one direction following the shape of the trunk or branch. The repetitive grain design is often altered by knot holes, scars and irregularities in the tree. The wood grain flows around and incorporates such disruptions into the overall pattern.

Marble

Agate

Wavy line patterns work well to suggest:

* Wood grain and mineral patterns in marble and agate
* The veins in corn leaves and grass-like leaf blades
* Water rings and tree rings
* Feather barbs
* Long, wavy hair

Feather barbs

Wood

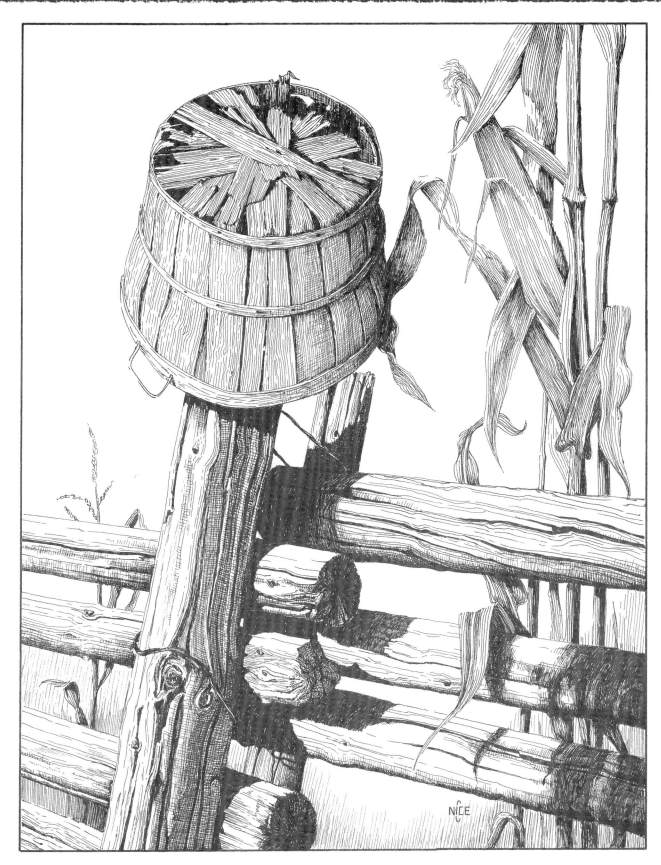

Bushel Basket on the Fence

This ink drawing was made using a technical pen with nib sizes .25mm and .35mm on drawing paper.
Wavy lines were used to suggest wood grain and corn stalk fibers.

THICK, FLEECY TEXTURES

When you need a soft, layered texture to enhance your drawing, think scribble lines. Keep the loopy lines spontaneous and free-flowing, resisting the temptation to work in a repeated pattern of squiggles. To soften the edges in an ink drawing, spread the scribble lines further apart or break them up. Blending with a paper stump or tortillion works well to create a light, fluffy appearance when using pencil or charcoal.

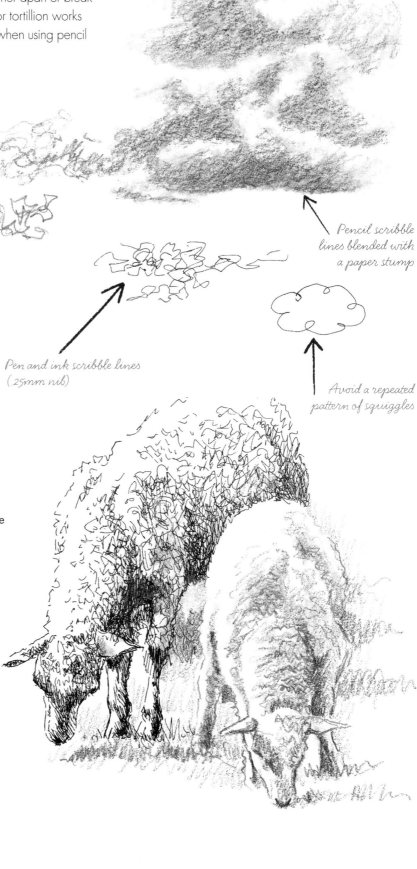

Scribble lines

Scribble lines using the point of a pencil

Pen and ink scribble lines (.25mm nib)

Pencil scribble lines blended with a paper stump

Avoid a repeated pattern of squiggles

Scribble lines work well to make quick, loose sketches and to simulate the texture of:

* Wool and fleecy animal coats
* Cumulus clouds
* Dense undergrowth
* Clusters of distant foliage
* Lacy, umbel-shaped flower heads
* Tangles of weeds
* Moss and lichen
* Foam and white water

154

Scribble lines work especially well in simulating the look of distant clumps of tree foliage. Alternating patches of dark shadow shapes and open areas behind the clusters of foliage will add a sense of depth to the scene.

Scribbled with a 4B pencil point

Softened by rubbing with a paper stump

HAIR AND GRASS BLADE TEXTURES

Criss-cross strokes (randomly crossed lines that are slightly curved and extend in the same general direction) are good for suggesting both hair-like and grass-like textures. As you can see in the examples at right, the longer the strokes, the more they curve and lay across each other. They should be arranged in expanding patches (B) rather than straight rows (A), which tend to look contrived and unnatural. Note in the cat drawing that the criss-cross lines are only as long as the actual hairs would be and that they flow in the direction of hair growth. The change in hair direction is subtle, so that the lines do not crosshatch abruptly over each other.

Pencil point

.25mm pen

A

B

Grass strokes get shorter and less numerous as they recede into the distance, until streaks of horizontal shading marks take their place.

Bengal Brothers

A .25mm technical pen and delicate criss-cross lines are used to suggest these bengal cats' soft fur. To form the darker spots and stripes, just move the lines closer together. Use scribble lines to suggest the textured blanket underneath and behind the cats.

Index

Ideas. Instruction. Inspiration.

THESE AND OTHER FINE **NORTH LIGHT** PRODUCTS ARE AVAILABLE AT YOUR LOCAL ART & CRAFT RETAILER, BOOKSTORE OR ONLINE SUPPLIER.

Down By the Sea with Brush and Pen

by Claudia Nice

* ISBN 978-1-60061-163-6
* Z2523 | Hardcover | 144 pages

Drawing for the Absolute Beginner

with Mark Willenbrink

* ISBN 978-1-60061-676-1
* Z4744 | DVD | 71 mins

The Artist's Magazine

Find the latest issue on newsstands or visit www.artistsnetwork.com/magazines.

Receive a **FREE GIFT** *when you sign up for our free newsletter at www.artistsnetwork.com/newsletter_thanks.*